D0148333

The Search for Aesthetic Meaning in the Visual Arts

The Search for Aesthetic Meaning in the Visual Arts

❖❖❖❖❖

The Need for the Aesthetic Tradition in Contemporary Art Theory and Education

DAVID KENNETH HOLT

Bergin & Garvey
Westport, Connecticut • London

BH
39
.H5745
2001
44812114

Library of Congress Cataloging-in-Publication Data

Holt, David Kenneth, 1947–
 The search for aesthetic meaning in the visual arts : the need for the aesthetic
tradition in contemporary art theory and education / David Kenneth Holt.
 p. cm.
 Includes bibliographical references and index.
 ISBN 0–89789–773–0 (alk. paper)
 1. Aesthetics, Modern—20th century. 2. Art, Modern—20th century—
Philosophy. I. Title.
BH39.H5745 2001
701'.17—dc21 00–060892

British Library Cataloguing in Publication Data is available.

Copyright © 2001 by David Kenneth Holt

All rights reserved. No portion of this book may be
reproduced, by any process or technique, without
the express written consent of the publisher.

Library of Congress Catalog Card Number: 00–060892
ISBN: 0–89789–773–0

First published in 2001

Bergin & Garvey, 88 Post Road West, Westport, CT 06881
An imprint of Greenwood Publishing Group, Inc.
www.greenwood.com

Printed in the United States of America

∞™

The paper used in this book complies with the
Permanent Paper Standard issued by the National
Information Standards Organization (Z39.48–1984).

10 9 8 7 6 5 4 3 2 1

Augustana College Library
Rock Island, Illinois 61201

*I wish to dedicate this book
to my mother,
Elsa Hoffman.*

AP20 2/15/01

Contents

Introduction

Arthur Danto in *After the End of Art* states: "contemporary art unlike all art prior to it, is post-historical, that is, it lacks a stylistic unity and narrative direction."[1] Contemporary artists, according to Danto, live in an art world that allows for a total freedom of expression, in that there is no manifesto that creates priorities or levels of quality in art and that, in short, anything goes. He equates this state with a hope that all social institutions and society-at-large should become as free and egalitarian as the art world has become. But should this freedom be classified as artistic or intellectual? This appears to be a central problem with Danto's assessment as well as a problem with the Post-modern world and Post-modern art theory in general. Isn't Arthur Danto really expressing the belief that contemporary artists have a level of intellectual freedom unequaled in history? But this should not be confused with artistic freedom. It is the author's belief that artistic freedom requires more than total intellectual freedom; it requires that artists do not arbitrarily adopt beliefs about art that contradict art's primary purpose for mankind. Later Danto briefly refers to these qualities. He states:

> It is quite possible that human beings will always express joy or loss through dance and song, that they will ornament themselves and their dwellings, or that they will always mark with rituals that verge on art the momentous stages of life—birth, the passing into adulthood, marriage, and death. *There may even be theories of art to account for the importance art is perceived to have in the common course of things.* (italics added)[2]

However, he adds, "I have nothing to say about this at all."[3] This omission by Danto is indicative of a major problem with current art theory, in that it ignores the role that art has played and continues to play in people's lives. The institutional theory of art which was developed by Danto and by George Dickie disregards the concept of the inherent value of art, and in so doing, defines art without an adequate evaluative component. According to Danto and Dickie, one should define art analytically and not sentimentally. This is accomplished by defining art only in a classificatory sense and not in an evaluative one. There is a problem with this understanding of art as well as other non-evaluative theories of art. Although they may be valid within the scope of their fields of origin, post-Kantian, post-Wittgensteinian analytical philosophy, and European symbol or language theory, they are inadequate in expressing the concept of art as it is practiced by artists and perceived by the public. They fail not for their lack of precision but their lack of scope. One must realize that this reductionist view contrasts sharply with previous art theory. In his *History of Art Criticism*, Lionello Venturi described what he believed to be a tradition in aesthetic thought from Baumgarten to Croce of a link between art and emotion rather than a totally logically based experience. He states:

> If not by a point it could be represented by a line from Baumgarten to Croce. The autonomy of art has been recognized and made to consist in a spiritual activity, an activity creative and not imitative, distinct from logical activity. To logical activity belongs the rational activity, as to aesthetics belongs the imaginative or intuitive activity.[4]

Venturi's acceptance of this tradition, that art can be adequately understood only by considering it to be concerned with intuitive activity is, of course, in direct opposition to contemporary Post-modern views on art and aesthetics. A central concern for Venturi was that a growing Positivism (as practiced by theorists such as Hippolyte Taine), was having the detrimental effect of creating an age where one had lost the consciousness of the autonomy or specialness of art that had existed since classical times. It was the absolute determinism of Positivism that eliminated both the autonomy and distinctiveness of aesthetic experience from other cognitive experiences. Art had become predetermined not by the genius of the artist but by race and environmental factors. The concept of art as an intuitive and transcendent activity was being threatened. The threat in today's Post-

modern art theory is also determinist but not positivistic in the same sense as the one facing Venturi in the early part of the twentieth century. It is rather one of total abandonment of aesthetic experience and its necessary connection with artworks.

It is the belief of the author that Post-modern art theory is an anomaly in the history of art theory. It can be thought of as antiaesthetic, and is, in part, based on questionable and unreflective premises. It is also the by-product of a Kantian Zeitgeist whose ultimate legacy has been one of placing a dogmatic emphasis on the subjectivity of experience, and away from the concept of a transcendent aesthetic. This has become the normative approach of most Post-modern art theorists and critics. Under the influence of Post-structuralism, there is only an interest in interpreting works of art as symbols akin to language, that carry meaning or reference. One does not judge a work as an individual entity or artifact but interprets its meaning through the relation of existent symbols. An arbitrary separation has been made between content and form. The artist is no longer a creator of original work, the prime mover of the artistic process, but rather an arranger of pre-existent images or signs.

The Post-modern appropriation of questionable beliefs and the reaction to other beliefs has contributed to producing an art theory that is primarily about meaning and not value, political rather than aesthetic. It is in large part literal and materialistic—not visual and transcendent. Losing sight of the traditional aesthetic link between art and mankind's emotional life has helped establish a state in Post-modern art theory of dogmatic materialism and relativism, with regard to the sources and subject matter of art. Because of the popularity of modern analytical philosophy and semiotic theory in contemporary Post-modern aesthetics, an uncritical policy of relativism has been put in place. Questions in aesthetics such as the almost universal appeal of some masterpieces of art go unaddressed because they are unpopular to address or explain adequately. In fact, all questions of quality and value go unaddressed. The end result of these omissions is that many artists are led astray and are advised to produce work that reflects nothing more than a perceived social reality. There is no consideration of the traditional desire among artists to create universal images of life, which transcend personal experience and personal ego. There is little or no direction for artists or for those who wish to perceive art in its totality and grandeur.

This state of Post-modern relativism has affected not only the professional art world but all those concerned with how the arts are

taught in the schools. Art education in particular runs the risk of being taught superficially, failing to take into consideration the aesthetic tradition of the visual arts.

The art educator must realize that the sources for art have historically been concerned with both the transcendent and universal in nature. Without this broader focus, art education runs the risk of becoming antiaesthetic. When art theorists refuse to consider or emphasize the aesthetic dimension of artworks, they run the risk of ignoring much of art, even potentially great art, because it does not fit into the narrow framework of acceptability established by current political pundits. Many of the works that receive approval from this narrow point of view may not be otherwise critically evaluated. Since its origins in early history, with myth, ritual, and religion, art has always been *connected intrinsically with the aesthetic and transcendent.* The fact that this view is in conflict with current Post-modern theory emphasizes the need to study how Post-modern ideas on art have become accepted. Regarding its lack of scope, art theorists should "formulate the definition of art in its universal meaning,"[5] as Venturi stated. But to do that Post-modern theory must consider the possibility that there are realities beyond one's ego, that humankind may not be locked into a subjective world of its own making.

When one looks at the history of aesthetic theory, many things are revealed. Not only does the acceptance of the concept of a transcendent aesthetic experience become apparent, but many of the prominent theorists, critics, art historians, and artists express a type of perception and experience that is inherently opposed to one's usual logical functioning.

The concept that the experience of art is somehow unique or different from our usual cognitive thinking has been described by many philosophers and art theorists. Bosanquet, in his *History of Aesthetics* believes the concept might have started with Homer's description of the shield of Achilles, "although it was made of gold; that was a marvelous piece of work."[6] Although we will never know the exact meaning intended, supporters of aesthetic experience believe it is a statement expressing a distinct type of experience, a heightened form of thinking that differs from our usual and rational thinking. It is thinking that centers on our almost total absorption in an object of beauty with the exclusion of thoughts about practical duties of our existence.

There has been a traditional belief in aesthetics that aesthetic experience is different, that the purpose of an artwork is to touch our senti-

ments and not our reason. Beginning with Plato's condemnation of the poets for lacking knowledge, this separation can also be seen in Plotinus's belief that artists were intuitively inspired rather than rational communicators of God's qualities. Baumgarten's separation of aesthetics as a distinct branch of philosophy is more evidence of the belief in the uniqueness of our aesthetic experiences with art and nature.

Many of the writers on art that support the concept of an aesthetic experience were not professional art critics. Since our modern conception of the art critic actually began in the eighteenth century in France with the reviews of the Royal Academy salon shows, this would be impossible. They were humanists, scholars, historians, amateurs, painters, poets, collectors, as well as art critics. What they showed was an involvement and love for the visual arts and a concern for what they believed to be its unique qualities. Therefore I will refer to these individuals as art theorists and art critics when that is applicable. Since my position is at odds with Post-modern art theory, my emphasis will be on those theorists and critics that helped to create and develop the tradition of aesthetic perception of the visual arts. In particular, the ideas of those theorists active prior to the formation and final consolidation of a Kantian metaphysic offer a claim for universality in art that stands in sharp contrast to current Post-modern views. A reconsideration of Kant's metaphysical position with regard to art theory will also be considered. My reason for looking into the tradition of the aesthetic is primarily based on my desire to explain my own dissatisfaction with Post-modern art theory and its potentially negative influence on art education. I believe that for all those who find any or all of the arts central to life, and wish to pursue or search for meaning in the arts, Post-modern art theory is unresponsive and unhelpful.

I limit discussions to those art theorists and critics who were concerned primarily with the visual arts. Although the various arts share similar concepts and possibly similar aesthetic experiences, they remain uniquely different, and must be dealt with within the context of their own histories and traditions.

It is not a coincidence that many of the theorists to be considered expressed a strong emphasis on the importance of vision and the uniqueness of sight over the other senses; from Alberti to Diderot, from Ruskin to Greenberg, visual perception was a defining aspect of their aesthetic theory.

I believe that the most glaring fault of Post-modern theory, oddly, is its lack of scope. While trying to include new and evolving forms of visual art, the Institutional theory of art, as well as the Post-modern

approach, in general, fails to express or consider concepts and the motivations characteristic of art and the creative experience. The process of artists and the aesthetic perception of the viewer remain largely outside of consideration.

Finally, the need in humankind to create art, to find meaning in art, seems lost to Post-modern art theory. It is the desire to find this meaning, to search for an understanding of art in its totality, that must be ultimately addressed by all those responsible for teaching the arts.

1

Intuition in Aesthetic Appreciation

Louis Duranty in "The New Painting," quotes or, rather, misquotes Denis Diderot (his Salon of 1765): "I see nothing in nature that is not beautiful." Diderot never said this; instead the correct quote is something quite different: "I see nothing in nature that isn't true."[1] This seems a small mistake, but it is indicative of a much broader problem of not only misunderstanding the thought of Diderot, his idealism and his realism but also the problem of understanding art as a concept that involves more than a naturalist interpretation of nature. Although realists and naturalist writers like Duranty saw Diderot as a foundational "father" figure, they had to selectively interpret him and omit his concern for the vital, the ideal, and the transcendent. Diderot's interest in materialism, and particularly visual perception, was seen to predetermine the conditions necessary for *The New Painting*. His interpretation of Diderot's realism reflects Duranty's own positivist orientation rather than Diderot's point of view. For Diderot, nature was not categorically beautiful and it was necessary for artists to selectively isolate and concentrate on only the beautiful and vital aspects of a larger empirical reality.

This is not to omit the similarities between the two art theorists. Both believed that art should be empirically realistic, and Duranty's criticism of the French Academy sounds similar to Diderot's criticism of the Rococo. Duranty's statement "the theatrical grimaces for the faces (are) . . . invariably the same" could have been made by Diderot concerning the Rococo artist François Boucher.[2] Both theorists wanted to eliminate copying from ancient models, to avoid the mannered or untrue and to depict the "real" empirical world. The problem was that what could be theorized as "real" at the time of Diderot was all but

impossible by the late nineteenth century. The "real" became only that which could be perceived scientifically or by using a scientific method of thinking without regard to other sources of knowledge.

For both theorists, artists used their imaginations in the production of art. Duranty believed that the imagination was always a good with regard to the creative process. It was in fact the creative process itself. It was an ability to be spontaneous, to free oneself from the constraints of convention, and thus to capture "the spectacle of reality." But it was clear that this mysterious concept was a trope to Duranty, since it both involved the careful observation of sunlight and "captur[ed] the spirit of the age."[3]

Diderot had a more limited interpretation of the "imagination" than Duranty. He used it not in the modern sense of the term but in a manner similar to Locke's "fancy." It was necessary but not sufficient in the production of great art. An artist produced a beautiful work of art through a combination of factors: close observation, hard work, a use of the imagination, and the ability to rediscover one's first thoughts. The imagination, according to Diderot, could lead to both good and bad art. It in fact helped cause the mannerist work that he abhorred as well as the work he believed expressed the vital, true, and beautiful. According to Diderot, it was necessary for artists, as well as those who wished to experience their work, to tap into an objective natural energy and vitality that was internal to nature. The ultimate objective of artists was to express this vitality and it could not be done by simply interpreting nature subjectively, using the imagination. Rather, the artist must observe nature and also "intuit" an objective vitality found in it. He described this objective vitality by quoting Virgil: "It is a spirit that resides within that is infused throughout the mass, that animates it, and that coalesces into the great whole."[4]

Contemporary Post-modern art theory has made the same mistake as Duranty has in losing sight of the transcendent in nature and art. The sources for art have historically been concerned with both the transcendent and the universal in nature. Without this broader focus, Post-modern art theory has become oddly nonrepresentative of the artistic process both past and present. An art theory overly influenced by the subjectivity of analytical philosophy and linguistic symbolism is unsuitable for understanding the revelatory, mysterious, and spiritual nature of art and the creative experience. Not only has Post-modern art theory ignored the role of intuitive thought in the creative process, it has attacked the very concept of originality itself. One is left to believe that the creative process is not really creative at all. Instead

of being the creator of original work, the prime mover of the artistic process, the Post-modern artist is thought of as an arranger of pre-existent images or signs. Artists are incapable of originality because their art is predetermined by factors over which they have no control. Their minds are not their own but rather the depository of other artists' ideas both past and present. They merely think they are being original; they are really unaware that they are plagiarizing other artists' ideas and are immersed in a world of pre-existent images.

Diderot's art theory, in particular, has suffered from both a misunderstanding and an oversimplification. Part of this is no doubt because Diderot was both a materialist and an idealist. One can easily accuse him of being an inconsistent or contradictory thinker in this regard. But this alone is not the primary reason that Diderot's ideas seem so distant from our own. The real cause is the direction philosophy has taken since the Enlightenment. In particular, the philosophy of Immanuel Kant has separated us from Diderot's world and made misinterpretations like Duranty's understandable. Kant did not intend his philosophy to lead to a world of subjectivity, nor did he intend art to be considered in that manner. In fact, his third critique emphasized the difference between judgments made of artworks from judgments that were solely personal and subjective. But the total effect of Kant's philosophy was to end traditional metaphysical speculation, to limit what was understood as knowledge or thought, and ultimately to declare that the material world was unknowable.

With Kant's system in place, knowledge both analytic and synthetic was preserved from Hume's skepticism, but something was lost in the process. Not only were metaphysical speculations ultimately doomed, but the almost total acceptance of Kant's ideas had the result of locking mankind into a world of subjective idealism and making it difficult to understand and appreciate philosophers like Diderot whose metaphysical speculations were an integral component of their philosophy.

By maintaining a flexible and hyphenated metaphysical stand fluctuating from materialism to idealism, Diderot captured a quality foreign to Kant's system. Besides capturing the duality of nature itself, both matter and energy, atoms and spirit, he captured the purposefulness and materiality of nature that is impossible to express by maintaining either an idealist or a materialist position alone. To understand art, in all its complexity, it may be necessary to return to a metaphysical position similar to Diderot's, and suspend one's judgment of any one metaphysical position. One must take a position that metaphysical theories are provisional and in some sense akin to scientific thought

in that one position is never absolute. This not only frees us from the limitations of Kant's philosophy but also captures modern scientific views on the nature of existence as both matter and energy, material and immaterial. But most important, it allows one to contemplate the possibility that thought can be more than subjective; that it can also be transcendent and intuitive. This possibility needs to be reintroduced to contemporary art theory and art education: intuitive thought can be acknowledged in Post-modern times.

The bases of all thoughts and judgments, including those concerned with the arts, may be intuitions that are unintelligible. A belief in the unintelligibility of first thoughts or intuitions should not be confused with mysticism. Mysticism is an irresponsible basis for belief because it need not conform to empirical verification (and is based on only a mystical experience). A belief that intuitions exist, that all reasoning is based on unrefined feelings or precognition, is not mysticism unless it fails to conform to empirical verification and experience.

It is quite reasonable to believe that at the base of our cognition and that which influences all our thoughts and judgments are these first thoughts that are primitive in the sense that they are not in our rational consciousness. They may not lend themselves to categorization or even conceptualization, but they are both active and expressive. All our rationally advanced thought is colored by them, and yet they remain largely undefined in a mitigated position between mind and matter upon which life as well as art may well depend. As Steven Pepper's example points out, the refined data acquired by reading the temperature on a thermometer can never be separated from the primitive feelings of hot and cold which we all possess.[5] To ignore the possibility that intuitions exist would not only be dogmatic but would contradict the empirical importance that this type of mental activity has had in the history of art.

Kant's philosophy did not end speculative metaphysics immediately. In fact the group of idealistic philosophers, Georg Hegel, Arthur Schopenhauer, and Friedrich Schelling were followers. They ignored those aspects of his philosophy that would contradict the establishment of an objective reality. But this issue of subjectivity remains Kant's legacy to art theory and to Post-modern art theory in particular. This state, characterized by its lack of concern for the transcendent, universal, and objective is not solely the legacy of Kant, it is also in part the result of dualistic philosophy in general. When René Descartes eliminated the Aristotelian concept of "substance" and replaced it with a systematic but dualistic philosophy of mind and matter, he set

in motion an absolute separation between these two aspects of reality. As Benedetto Croce warned, "this division in philosophy would be irreversible and could lead to agnosticism."[6]

In addition to proposing that intuitions are central to artistic practice and appreciation, I am also asking the reader to adopt a rather unusual ontological position with regard to art, asking that one think of art both materially and ideally. One could argue that this is both logically inconsistent and extreme. Wouldn't a position incorporating both positions be desirable? For example, the contextualist position eliminates the necessity of a duality of mind and matter. Unfortunately, the contextualist position popularized by John Dewey is inherently flawed with regard to understanding the arts. Dewey's conception of contextualist aesthetics has had a great influence on twentieth-century art theory and art education. Some have linked his views in *Art as Experience* to many of the artistic practices of the twentieth century, including, but not limited to, an emphasis on process over product exemplified by happenings and installations.

The most characteristic model for contextualism is, of course, "an experience." Dewey meant an experience to be a historical event. Not an event of the past but, rather, an ongoing event. The important consideration was that it was a unified event, an indivisible unity between mind and matter that could not be broken down further into its constituent parts without distortions. A consideration of objective matter and subjective mind lay out of the scope of contextualism. This is because both aspects cannot be considered separately.

The second problem with contextualism lies in its acceptance of categorical change. In contextualism, it is necessary to validate each new experience, in a sense to compare it with each previous one, because each new experience is considered different from each previous one. The concept of a universal experience is dismissed. Although contextualism successfully ends the problem of a dualistic philosophy, where one side (the mind) can be proven where the other (matter) cannot, it is unsuccessful as a sole basis for an aesthetic theory because its emphasis on change makes it inherently incapable of validating that which is unchangeable or universal. Despite Dewey's own Idealist learnings (he was heavily influenced by Hegel), contextualistic aesthetics is ultimately subjective and categorically concerned with change.

Although a universal masterpiece cannot exist for Dewey (having to be proven with each new encounter), his philosophy is not one of total subjectivity. Dewey's own belief in Objective Idealism, inherited

from Hegel, often objectifies an otherwise subjective and personal "Experience." He often suggests a spirit or intuition that underlies aesthetic experience and that can enable this experience to offer mankind the instrumental value of greater self-understanding and empathy with others.

He states:

> A work of art elicits and accentuates this quality of being a whole and of belonging to the larger, all-inclusive, whole which is the universe in which we live. We are, as it were, introduced into a world beyond this world which is nevertheless the deeper reality of the world in which we live in our ordinary experiences. We are carried out beyond ourselves to find ourselves.[7]

But Dewey's concept of Experience begs the question of how one can account for this broadening of human perspective. If there is a reality that exists outside our ego, it must be searched for and "contextualism" does not address that search. Perhaps the model of contextualism lacks scope, in that it is inherently about the benefits of change over an understanding that reality can contain universals.

Contextualism eliminates all dualities but fails to make necessary distinctions. The experience of an artist creating a work is considered similar to the experience of the attending viewer or perceiver. The artwork, not the experience of the artwork, is ultimately credited with assisting mankind to go beyond the ego, to increase imagination and imaginative projection; the work is never considered as matter itself, only as an aspect of an indivisible experience with mind.

One is left with the concern that no metaphysical positions are necessary and sufficient to understand a concept so tied to essential human action as art. The model of the biological experiment may have started contextualism as a philosophy, but it also convinced Diderot that nature had a purposefulness that defied a mechanist or materialistic interpretation. His solution was to consider matter both materially and spiritually (ideally).

If objective intuitions are understood to be of central importance to the visual arts there must be an acknowledgment of both a material and an idealistic position. A provisional and changing metaphysic is the only solution to maintaining both the material and spiritual in art.

2

Aesthetics

Arthur Danto expressed the belief that there has been and continues to be a war between art theorists, critics, and others concerned with the production of art and philosophical aesthetics. This war has existed since the first serious philosophical writing on art. Plato's book 10 of *The Republic* established the idea that artists had no real knowledge of what they imitated, were concerned with appearances only, and were potentially dangerous to society. His idea that artistic thinking was inferior to rational thinking has existed ever since, and thus the yoke of philosophy has been applied to art through philosophical aesthetics. Danto concluded that there is a need to liberate art from being pseudo-rational and to deal with art theory and criticism as a different type of thought that is not subject to this negative preconception of inferiority.[1] Danto makes the further distinction that perhaps the antagonism between the two disciplines lies in the fact that the aim of philosophers is to prove and the aim of art and rhetoric (which he links together) is to persuade.[2]

I would agree with Danto that philosophical aesthetics, with its emphasis on consistency and clarity in argumentation, would find the practices and appreciation of art troublesome. But I would also argue that the creation of philosophical aesthetics was also in part motivated by the desire to maintain art's independence from rational cognition.

Aesthetics is an outgrowth of the ancient philosophy of the beautiful inherited from classical times through the Renaissance. The study of art under a branch of philosophy called Aesthetics can be thought of as an attempt by eighteenth-century philosophers to "rationalize" art but also to acknowledge its autonomy. This could have been sparked by an overall greater interest in deductive reasoning and the

discussions primarily in the French academy concerning the "je ne sais quoi" quality of art that was indefinable but a cause of excellence. During the seventeenth and eighteenth centuries the sense that art and reason were incompatible grew. Jean-Baptiste Du Bos stated that reasoning intervenes in the judgment we give a poem or a painting only to explain a decision based on sentiment or the emotions.[3]

It was this aspect of reason, its inability to illuminate feeling, that promoted the creation of philosophical aesthetics. Venturi believed that the aesthetics of Vico and Baumgarten originated in a reaction to Cartesian rationalizing as opposed to a forcing of a Rationalist agenda. The Rationalist tradition believed that knowledge derived through the senses was an inferior form of cognition, that it was as confused and complex as nature itself. The terms "beauty," "decorum," and "imitation," as well as many others, defied precise explanation when they were applied to the arts.

It is this spirit of allowing art to be transcendent, as well as a concern for its autonomy, that has been lost to Post-modern theory. Art theory has had the problem of overrationalizing art, as Danto has noted, but this could have both good and bad consequences.

In commenting on the loss of creativity in the Neoclassical period of the late eighteenth century, R. G. Saiselin argued that it was caused by the progressive hardening of the term "imitation" until it came to mean "copy."[4] At least with this example, the clarifying of an artistic term may have contributed to the adoption of noncreative artistic practices.

But one must not conclude that philosophical aesthetics is always or usually detrimental to artistic practices; it can also be helpful. Venturi believed that rationalism fused with Neoplatonic mysticism produced conceptions of ideal beauty that put an end to Rococo sensism.[5] It is possible to see philosophical aesthetics as potentially beneficial to artistic production but only when it considers the transcendent as an aspect of its aesthetic theory. While recent art theory is at odds with artistic practices it is my belief that Baumgarten carefully separated aesthetics from other branches of philosophy as a protective act, preserving the understanding that art was to exist with special qualifications; that is, that it was in part concerned with qualities defying complete clarity and that it is concerned with nonmediated or intuitive thought.

An art theorist or teacher of the arts must resort to using definitions for artistic practices that appear to defy necessary and sufficient properties in the traditional sense. Complex cluster concept definitions, or in some cases, examples or models may be needed to understand as closely as possible the meanings of concepts such as aesthetic experience, beauty, quality, or intuition in art.

So much of what humans understand about art is involved with thought that is intuitive and difficult to define adequately. Theodore Green states, "The unique character of the artistic quality of a work of art can only be immediately intuited, and though it can be exhibited and denoted, it cannot be defined or even described. But though analysis cannot define artistic quality itself it can exhibit some of its determining conditions."[6]

Arnheim has noted that philosophers have long considered the mind as possessing two functions: a reflective (mediated) process and an intuitive (nonmediated) process.[7] Artists appear to use both processes in the creation of their work. Their consciousness is often not mediated by any other concept and they often do not follow a preconceived set of procedures that is more characteristic of our usual rational thinking.

Aesthetics as it exists in Post-modern times does not consider intuitive thought or the transcendent, and is therefore at odds with the practices of artists as well as the public. Many artists resist the idea that they are mere manipulators of symbols, or the belief that there is no real conception of aesthetic experience, as well as the belief that creativity is predetermined and predictable, and that there is no possibility of the transcendent and spiritual.

While philosophical aesthetics has sought to understand art, its appreciation as well as its creation, it has failed in part to obey the original mandate established by Baumgarten and others to maintain art's autonomy and necessary connection with aesthetic experience. An art understood without an aesthetic response limits one's understanding of the benefits that art has traditionally offered mankind. It is these benefits that must by necessity concern art education if that education is to fulfill its societal responsibility of introducing the young to the benefits of aesthetic consciousness.

Current Post-modern theory is too involved with issues arising from subjective interpretation and not at all concerned with a traditional understanding of art and aesthetic experience. It lacks the scope necessary for one to understand art as a complex human activity. The idea that artists and those who perceive their art think aesthetically has been well documented by a tradition of theorists who linked art with intuitive thought and aesthetic experience. We now discuss that tradition in depth. We begin with Leon Battista Alberti, who, more than any art theorist, was responsible for reviving classical ideas on art and the beautiful.

3

Leon Battista Alberti

Leon Battista Alberti, more than any other Humanist, took a special interest in the visual arts and architecture. He became an occasional artist and a successful architect as well as the advisor to painters, sculptors, and architects. He was in fact knowledgeable and successful in many fields outside his ethical and aesthetic writings. But perhaps his greatest accomplishment was that he was central to reviving classical aesthetic thought and contributed toward a revival of aesthetic consciousness that had been suppressed during the Middle Ages.

Alberti has been and continues to be of particular interest to art historians. Jacob Burckhardt described him as the quintessential Renaissance man. Later art historians have questioned this assessment, noting that he had medieval as well as more modern features in his literary work.[1] According to Paul-Henri Michel, there existed no unifying principles in Alberti's diversified corpus, only a conflict between old and new. One can only hope to capture the essence of Alberti by looking at him as a transitional figure who did not have a consistent point of view. Other writers have questioned this assessment and believe that it fails to capture his optimism and faith in the power of work, as well as his unified vision. Joan Gadol states, "it is the work of virtue, the making of the good life, to which Alberti consistently returns."[2] She concludes, "ideas of measure, harmony, and proportion are contained in all his writings."[3] Where others might see a conflict inherent in Alberti's mixture of Idealism and Empiricism, Gadol sees it as emblematic of his Stoicism. This Stoicism necessitates his commitment to a priori and universal ideas of virtue and beauty, as well as to Florentine empiricism and business acumen.

The notion of an inherent conflict in Alberti has more recently been described by Mark Janzombek.[4] Utilizing an approach influenced by Structuralist and Post-structuralist theory, he concluded that Alberti was keenly aware of the artifice inherent in symbolization. Alberti's objective, according to Janzombek, was to return ethical writing to a quasi-religious activity.[5] But this objective was never free of Alberti's own awareness of the existential chasm between being and image. According to Janzombek, Alberti's "painful awareness" of the deviation between being and image, subject and object, word and meaning, was to a large extent the rationale and impetus for his moral writings. He was forced to create a "superstructure" of moral writings to combat the "wandering signification inherent in an amoral creative process."[6] Janzombek illustrates this by stating that "the myth of Narcissus" in *De Pitura* takes on a more negative aspect with Alberti, in that it recalls not only the genesis of sight and mimesis but also the awareness that the process of creating material objects was devoid of ethical considerations.[7]

Art historians can fall victim to a contemporary ethos and thereby interpret an artist within the context of contemporary times rather than considering the social conditions of the artist's own time. A startling example is that of the American painter Charles Sheeler. Sheeler has traditionally been portrayed as an artist emblematic of the success of American industrialization during the first half of the twentieth century. But in more recent monographs concerning Sheeler, a new interpretation has irrationally emerged.[8] Considered from this new point of view, Sheeler is a political artist, a critic of the industrial age, utilizing his art for the purpose of advocacy or action. The fact that the artist's own writings never mention any interest in political content appears to be ignored. There is a tendency in writing about artists (or any outstanding individual) to offer a new interpretation that would shed light on some new aspect of the individual previously ignored: the idea that knowledge is cumulative and, like all research on a subject, never essentially resolved. The problem with this attitude is that it is often counterproductive, undervaluing those interpretations previously established. There is the impetus for change even when that change may not be warranted.

It is clear that this new Post-modern interpretation of Alberti reflects late twentieth-century philosophical ideas and is not reflective or representative of the concerns that would have faced an Italian Humanist of the fifteenth century. Even if one accepts the belief that early historians may tend to glorify or idealize those outstanding individu-

als of the past, their assessments can be corrected without the loss of the character of the individual discussed.

In Alberti's autobiography, "Anonymous Life of Leon Battista Alberti," written in mid-career, he describes himself as a man confident in his abilities and optimistic that one can accomplish any task. He describes himself as faithful to the great principles of classical antiquity, of being sincere, naively enthusiastic, faithful, thorough, and hard-working.[9] He describes himself as not only intellectually successful, but also capable of great feats of physical endurance, such as riding for hours without fatigue. He is also dedicated to giving back to mankind the "fruit of his studies," and asks himself, "what do you do in a year that is of use to mankind."[10] I believe Alberti's writings reveal a true Humanist who possessed a point of view and attitude to humankind's abilities that differ significantly from Janzombek's assessment.

Alberti's self-described qualities seem to emulate Cicero's four cardinal virtues (which were adopted from Stoicism) of wisdom, justice, fortitude, and temperance. It is clearly evident that with regard to his ethical writings, Alberti was heavily indebted to Cicero. In particular, he also aspired to acquire "Tranquillita, or that state of serene contemplation acquired by raising oneself above the vicissitudes of fortune."[11]

When one recalls Alberti's early history, the influence of Cicero is quite understandable. Alberti's father died during his first year at the University of Bologna, and when his uncle died a few months later, members of his family took advantage of his illegitimacy and appropriated his inheritance. He was not only fatherless, but now rejected by his family and without money. A sixteen-year-old Alberti already introduced to Cicero's writings may have found solace in Cicero's ethical works. In particular, the orator's "On Duties" deals with a similar example of larceny. In it Cicero poses and answers a moral question: "If a man of great wisdom was starving to death, would it not be justified to rob from one who is useless?"[12] His answer for this or any other example of stealing was, "to rob even a useless person for your own advantage is an unnatural and inhuman action."[13] One can only imagine the effect that these classical concepts of correct moral action would have had on the young Alberti. The additional fact that "On Duties" was written by an absent father to his son attending school in Athens may also be significant in understanding the role Cicero played in Alberti's emotional and intellectual life.

The "Anonymous Life" also reveals a man who was keenly aware of visual beauty. He states, "he took extraordinary delight in looking at things in which there was some beauty or ornament," that "he

looked upon every skilled or beautiful product of man's invention as divine. . . ," and, "when ill, the mere sight of jewels, flowers or some pleasant natural scene would often cure him."[14]

Alberti's ideas on art and beauty came from late classical sources, particularly book 35 of Pliny the Elder's *Natural History*. Written during Hellenistic times, but emphasizing the classical ideals on excellence in the visual arts of the fourth and third centuries, it gave a romanticized account of the earlier time. Using a then-existent treatise on Ancient Greek art by Xenocrates (a sculptor living about 280 B.C.), Pliny described the glory that once was, before the inferior art of his day. He described the criteria for classical nemesis and the education or preparation needed to become an artist. According to Pliny, the final formulation of nemesis could be seen in the work of Lysippus and Apelles. The work of these painters displayed a faithfulness to nature but also possessed beauty and grace by selecting from nature only the ideal.

Alberti was also influenced by Vitruvius, Lucian, Euclid, and late classical writers such as the Neoplatonic Dionysius Pseudo-Areopagite and Boethius.

Alberti did attend lectures on Plato and Plotinus given at Marsilio Ficino's new academy, but Ficino's lectures on his translations were given after Alberti's literary career was over. In any event, he would have absorbed some of the content of the *Dialogues* and the *Enneads* from the secondary sources available to him. Most important, he absorbed the importance that aesthetic concerns had for late classical writers.

Alberti's treatises on art and architecture contain both Platonic and Neoplatonic ideas, as well as a Florentine emphasis on observation and correct perspective.

Unlike medieval treatises and copybooks that emphasized painting as a handicraft acquired by simply following the example of the master, Alberti understood the visual arts to be a liberal art possessing its own elemental rules. The systematic organization of *De Pitura* was also new, with three parts. It began with a simplified explanation of perspective meant for an audience of young painters, proceeded to parts dealing with an explanation of ideal imitation, and concluded with the importance of virtue and intellectual training for the artist.

Alberti's goal in writing *De Pitura* was simply to raise the status of the visual arts to the level of the literary arts. He wished it to be a subject taught at the universities, like poetry. Young artists, according to Alberti, need only to master perspective, mimesis, and virtue to achieve lasting fame.

The task of the artist, according to Alberti, was to discover the hidden beauty of nature. To accomplish this he must be educated. Alberti states, "I want the painter, as far as he is able, to be learned in all the liberal arts, but I wish him, above all, to have a good knowledge of Geometry."[15]

Painters must also be educated in literature, as this would be necessary for them to speak with educated men. They must above all not copy masterpieces but only nature, "since nature is the ultimate guide to invention."[16] To find beauty in nature the artist must be careful to select only the most beautiful and worthy, and not invent arbitrarily.[17]

The young artist, as well as a wide-ranging audience, could read Alberti's Italian version of *De Pitura* known as *Della Pitura* and understand the practices and training necessary for producing classical art. Alberti also helped establish other tenets of later classical art theory. These characteristics include, for example, the idea that history painting is the supreme achievement of the painter, the idea that color was secondary to drawing, as well as the idea that expression in the figure should be potent, but not violent or extreme.

Beauty was defined by Alberti as "the harmony and concord of all the parts achieved in such a manner that nothing could be added or taken away or altered except for the worse."[18]

Unfortunately, Alberti's practical approach to the subject nearly eliminates metaphysical content in his writing. For example, in book 1 of *De Pitura*, he did not speculate on the origin of the centric ray, a topic of interest to those concerned with medieval and early Renaissance treatises on optics. In spite of this approach, a Platonic and Neoplatonic metaphysic was implied throughout the work. Not only did he believe in a single and transcendent beauty, but he believed that beauty can be retrieved, experienced, and appreciated by a process of Platonic recollection.

Alberti not only expressed a confidence in mankind's natural abilities but also in our artistic abilities. He believed that almost anyone could attain fame for their art by following a process of experience and practice. Excellence in art was not necessarily governed by innate abilities.[19] The concept of individual differences in ability was not emphasized in his writings, only the power of work and purposeful action to correct errors. This attitude is in opposition to later classical, Romantic, and Modernist ideas about the power of genius and its necessary connection with great art.

To understand Alberti, the art theorist and teacher must be aware that his views on art were not only in agreement with classical ideas, but were also influenced by a strong mercantile and empirical practicality.

He was a reformer who believed that he was introducing a new "correct" perspective that would revolutionize artistic production.

One must also consider Alberti as being one of the key figures in reviving aesthetic consciousness for an audience of not only fellow Humanists, but also painters, sculptors, and architects. At the beginning of the Renaissance he established the importance of objective concepts with regard to education in the visual arts.

Alberti also exemplified a culture and society that could not conceive of beauty in any form as an end in itself. The striving for beauty was thought of as an integral part of the overriding search for virtue. The experience of art was both instrumental and valuable because it was pleasurable as well as informative of divinity, or God's virtues. He states in his essay entitled "Paintings": "The reader will not only delight in the painting's variety and the artists invention, but will be grateful I believe, when he finds our work pleasing and enjoyable counselor for living wisely."[20]

In spite of these moral qualifications, Alberti's writings on art and architecture describe a beauty and aesthetic experience that are universal, transcendent, and available. Beauty is inherent in a material nature and available to those who study nature and select only its normative features. It is a singular beauty characterized by perfect proportions and absolute unity, and, as mentioned earlier, everyone can recognize it because it is preexistent in our minds from birth.

Although pleasure as an end in itself was absent from Alberti's writings, he does make a clean distinction between pleasure and utility. He states, "what one admires of God's work is the beauty we see, rather than the utility we recognize."[21]

He states with regard to the practice of architecture, "We are forced to practice some of the arts by necessity, while others commend themselves to us for their utility, and still others we appreciate because they deal with matters that are pleasant to know."[22]

Alberti believed that the experience of art and beauty was distinct from one's usual practical experiences, and, despite the cultural bias about it, he consistently referred to the pleasurable dimension of aesthetic experience.

He states in *De Pitura*, "The painter will achieve this (praise) if his painting holds and charms the eyes and minds of spectators."[23] His meaning in the phrase "charms the eyes" is elaborated further when he describes an admirable "historia." It is one that is "so charming and attractive as to hold the eye of the learned and unlearned spectator for a long while with a certain sense of pleasure and emotion."[24]

Just how closely Alberti's description of this pleasurable experience conforms to a genuine aesthetic response can be understood when one compares his comments with Monroe Beardsley's twentieth-century cluster concept definition of the term. Beardsley was a strong supporter of the concept of an autonomic aesthetic experience that was both unique and separate from other forms of cognition. He defined it as an experience possessing four of five symptoms or qualities. *The most important and "necessary" quality was "object directness," that one attends to the work with a disregard for other activities: a single mindedness. The other remaining qualities, "felt freedom," "detached affect," "active discovery," and "a sense of wholeness," "deal respectively with a freedom from practical concerns, an emotional distancing, a sense of emotional satisfaction, and finally a sense of unity or completeness resulting from the experience"* (italics added).[25]

As mentioned earlier, Alberti's focus on practical methods in his writings on art minimizes his own personal responses to art. Yet he does on occasion reveal the nature and the value of this experience. In *De Re Artificatoria*, Alberti described the effect of a beautiful church. Wittkower summarizes: "it awakens sublime sensations and arouses piety in the people. . . . It has a purifying effect and produces the state of innocence which is pleasing to God."[26] In *De Pitura*, Alberti states:

> whenever I devote myself to painting for pleasure, which I very often do when I have leisure from other affairs, I persevere with such pleasure in finishing my work that I can hardly believe later on that three or even four hours have gone by.[27]

These comments and others reveal that the experience of beauty in art, architecture, and nature was personally pleasing to Alberti. The experience was also one capable of producing a "state of innocence" free of practical concerns, one that is charged with positive emotion, as well as an experience possessing a singularity and focus that makes one oblivious to time spent, in short, quite in keeping with Beardsley's definition.

There is a nondogmatic quality in Alberti's writings on art that is lost in later classical theorists such as Lomazzo, Bellori, or Winckelmann. Alberti acknowledged and reflected on the multiple facets of the creative act. He emphasized a mystic connection between nature and the imagination of the artist as opposed to an emphasis on copying ideal models, and also acknowledged the difficulty of varying the portrayal

of movements of the body "with the almost infinite movements of the heart."[28] One could argue the contrary also: that Alberti's writing at the beginning of the Renaissance contained the seeds for the dogmatism of these later theorists. Alberti clearly did not specify or establish a single distinct idea of beauty as, for example, Vasari did with Michelangelo, or Bellori did with Annibale Carracci, because there were no masters of their level during his lifetime. But I believe that there is a tension in Alberti's writings on art that expands on classical art theory and reveals his surprise or awareness over the difficulty in codifying art in rational terms. Although he was committed to the Stoic belief that the creation and appreciation of art is a rational activity, he was still aware of the fact that man's experience and motives are complex and not easily explained or revealed. Alberti believed that an artist may not be able to reveal the essence of a figure's thoughts by the appropriate physical presentation of the parts of the body. This is an admission that later classical theorists would strongly deny.

Alberti was above all else a seeker of aesthetic meaning in the visual arts. He was of particular importance in not only reviving a long-suppressed aesthetic consciousness but helping to create the foundations necessary for further development of both aesthetic concepts and aesthetic experience itself.

4

Giorgio Vasari and the Origin of the Image of the Artist

The intellectual and artistic climate in Italy changed dramatically in the 115 years between *De Pitura* and the first edition of Giorgio Vasari's *The Lives of the Artists*. Vasari published two editions of *The Lives* in his lifetime, the first published in 1550, the second revised version, containing more contemporary artists, completed in 1568. Platonic and Neoplatonic ideas had been disseminated into the intellectual and artistic community by Marsilio Ficino, a Humanist and founder of the Florentine Platonic Academy. In the sixteenth century, as opposed to the fifteenth, there was a greater interest in understanding the origin of the creative powers of the artist.

Vasari was not a theoretical or systematic thinker. There is little of what Vasari states that has not been said by previous art theorists, such as Alberti, but Vasari's writings do reveal the changes that occurred in Italian art theory after Alberti, and also some of the personality and uniqueness of the author himself.

The image of the artist active in Italy changed dramatically after Alberti's lifetime. Functioning under a guild system, they were considered merely skilled artisans in Alberti's time. By the time of Vasari they could sometimes work independently and dictate their commissions and prices. Mantegna even received a yearly salary as court painter to the Gonzaga family.

Artists like Leonardo and Michelangelo were respected for their intellect and knowledge as well as their artwork. Part of this change was, no doubt, the result of Alberti's fighting for the concept that the visual arts were to be studied and learned, the equal of poetry and true liberal arts. A new image of the artist was emerging as an educated individual,

independent of the guild system, who, in the case of the greatest of artists, could be divinely inspired.

Alberti believed perfection in the visual arts was the product of industry and knowledge. It required that the artist work and learn slowly and carefully. One should confer with friends throughout the process, asking advice, for example, on decorum or composition. Artists during Vasari's time, like Michelangelo, influenced by Platonic and Neoplatonic ideas, associated creation in the arts with rapture and inspiration rather than some sort of rational preplanning.

One can think of the climate of Italian art theory in the late sixteenth century as a combination of intellectual ideas concerning the relative merits of the visual arts such as sculpture or painting (the Paragon Debates), as well as a jumble of ideas concerning Platonic and Neoplatonic thought. I say jumble because the two views were not differentiated and, as Panofsky noted, it was not before Leibniz that a fundamental distinction between the two was made.[1] The problem with this mixture was that it was essentially contradictory. Neoplatonic ideas, emphasizing that the artist could think extrarationally or become one with divine mind, contradicted Plato's own concern for rational knowledge. At the same time this new emphasis on the spiritual and transcendent was colored by the accompanying ideas that the material world, the world of sense and perception, was equally important and contained divinity in it. The image of the artist as sharing a divine intelligence became dominant, and thus the image of the artist changed from a rational and quasi-scientific model possessing virtue and manners to an individual genius possessing divine mania through inspiration and grace. This latter individual often became associated with eccentric or melancholic personalities.

Giorgio Vasari wrote *The Lives of the Artists* at the request of Pavlo Giovio, bishop of Nocera, who rejecting the idea that he be the author, suggested instead that Vasari write a history of all the artists of the Italian Renaissance. The book was an instant success and remains the single most impressive accomplishment of the artist and author.

It is a book that contains little development of theory but rather a wealth of facts, descriptions, and evaluations of artists and their work. It also contains—and no doubt this is the reason for its wide appeal—entertaining anecdotes and gossip about the private lives of the greatest artists of the Italian Renaissance. Specific artworks are described in the historical order that they were produced, but their evaluations are usually brief and underexplored. The major emphasis is on the lives

and personalities of the artists, usually telling a story that reveals the personality of the artist.

The book is divided into three parts or periods from the rebirth of art by Giotto, after the decay of the Middle Ages, to the perfection of art in the third period or high Renaissance, epitomized by the art of Leonardo, Michelangelo, and Raphael. Vasari was concerned that the art of his time might not ever rise to the level that these men had achieved.

The book downplays the role of late Gothic, International style, and late Byzantine in bringing naturalism back to the visual arts and instead emphasizes the fact that Giotto's art represented a complete break from the art of his day. Vasari was correct in pointing out that Giotto, with Cimabue as a forerunner, was the important artist of his time, the one whose naturalistic style contributed most to the obsolescence of the Greek style. However, as future art historians have noted, he did carry on naturalizing tendencies already existing in the art of his time. Giotto initiated the first period of the Renaissance but Vasari helped initiate the emphasis on personality in art history. According to Vasari, the artist was capable of changing the world, as the agent of change acting upon the environment rather than being acted on. The artist as genius was guided not so much by the artistic influences of his time but by a link with divine creativity and grace.

The second period of the Italian Renaissance was characterized by artists such as Massaccio and Piero della Francesca, who improved on Giotto's work by improving imitation (the proper arrangement of figures and gestures to tell a story) and execution with better designing, style, and greater accuracy. The third period, initiated by Leonardo Da Vinci, showed the culmination of this evolution in naturalism containing still better invention, design, and coloring. Also with this period, the painter no longer relied on a linear outlining of his figures and instead, used soft shading or "sfumatezza," so that light remained shining only on the parts in relief.[2] Vasari's conception of the development of art history through his anecdotal stories about artists had a tremendous influence on art history as well as on how we still understand the artistic personality.

As an artist, Vasari's overall criterion for excellence was "verisimilitude in mimesis." His emphasis is almost always on the goal of making the image so real that "peacocks will peck at the painted strawberries or birds will try to land on painted branches."[3] It is the "aliveness" of the image that fascinates him, just as it was the living qualities of

Titian's work that made him reconsider its merits and include Titian in the second edition of *The Lives*.

Vasari was not a theorist but one can infer through his statements an emphasis and approach to classical theory that was uniquely his. Sound training, although important, was insufficient, in Vasari's opinion, to explain the appearance of great artists such as Michelangelo. Although his doctrine of mimesis was similar to those of classical authorities and of Alberti, it had a distinctively more spiritual and mystical emphasis that is not explored by the earlier writers. He states in the preface to *The Lives* that the origin of the visual arts was nature herself and that one must share the "divine light" of the master; with a special act of grace, "artists will make creations like God himself."[4]

This statement is revealing in that it shows that Vasari was influenced strongly by Neoplatonic ideas such as the practice of using the term "divine light" to designate God, as well as implying that artists share a particular communication with God that is unique and untaught. "Grace," as he later stated, is untaught. It is a gift given by God and it is not related to preparation, study, or even exposure to the material world. But this Neoplatonic conception does not characterize the practical and material emphasis that informs Vasari's thought on art.

It must be understood that Vasari is not without contradictions, and statements sounding very Neoplatonic, so fertile with spiritual meaning, must be considered in relation to a man and art world affected by Neoplatonism but still empirically oriented and Aristotelian when it came to the belief that an empirical nature freely experienced remains the origin and source of art. Neoplatonic ideas that the artist could communicate directly with God were endorsed by Vasari and helped perpetuate the idea, present during his own time, that artists could be divinely inspired. But the emphasis in his book is that art is dependent on the experience of nature and that all other influences follow, such as the need to study former masters and ancient sculptures. This preference for the study of nature over the achievement of others can be summed up in his adage, "Those who always walk behind rarely pass in front."[5]

Vasari believed that ancient sculpture, newly excavated from the ruins of Rome, had made the perfection of the third period possible. Thus the artist or artistic genius was in part grounded in the real world of experience, and was not totally divorced from the determining factors of time and place. But still the overall emphasis in Vasari was far from determinist. The artist must also possess the concept of grace and all that term would imply if they are to create work of the highest order.

Grace is a key critical term for Vasari. It is used synonymously with beauty throughout the book. The definition of the term "grace" to mean gracefulness is too slight to encompass the full scope of Vasari's meaning.[6] Grace has theological meanings relating to the fulfillment of the soul and it also includes the concept of what we would call elegance. Grace is a necessary component of great art and it is a quality that cannot be taught. It is outwardly characterized by facility and quickness of execution. Thus, Vasari establishes transcendent and universal criteria for beauty. It is a combination of an empirical ideal realism with a mystical conception of divine mind and grace.

The criterion of excellence that seems to epitomize Vasari's own artwork as well as that of the geniuses he describes is a quickness of execution, or the ability of an artist to work quickly and to solve difficult problems in perspective or invention and make it look effortless. This was an aspect of grace and was aligned with the standard of elegant behavior described in Baldassare Castiglione's *Book of the Courtier*. In describing the ideal behavior of the Italian nobleman (Raphael epitomizes this behavior among artists), Castiglione described elegant manners as being nonchalant but not affected. Noblemen were to be courteous to others but were also to perform acts with an ease that conceals their laboriousness. Social behavior should be governed by the ideal of "sprezzatura" or a kind of studied nonchalance. It was this conception of grace or elegance that Vasari believed the great art of the late Renaissance possessed.

Alberti believed that great art could be produced by study and effort; Vasari thought sound training to be important for artists, but a necessary ingredient of beauty was grace, and grace had no rules and could not be taught. Thus, Michelangelo, Raphael, and Leonardo were original geniuses that were beyond duplication by merely good academic training. They became idealized figures themselves. In fact they became celebrities, in the sense that they could no longer be considered part of the shared experience of common men, but rather they became figures who were at their very core romantic, mysterious, and original personalities that existed outside of the normal realm of other individuals. It is this mystique that determines how we still think about these artists today. Post-modern artists' concern for their own celebrity logically follows from Vasari's examples.

Vasari's own body of work as a painter was plentiful and reveals an artist who was heavily influenced by the contorted and crowded compositions of late Michelangelo and Mannerism. Typical of the work of Florentine Mannerists, his work has the elongated figures (a 1 to 9

proportion unlike the 1 to 8 classical model) and a freedom to experiment with gesture or "invention." The Mannerist period is in some sense similar to the nineteenth and twentieth centuries in that an atmosphere of experimentation was dominant. Although rules for painting existed, there was also an interest in playing with those rules to make work that would be equal to the great art of the third period. As he says, "the eye must give the final judgment."[7] The true artist "challenges" himself, draws figures without the model and takes liberties.[8] Following the tradition of fellow Tuscan artists before him, he believed that great art was also dependent on draftsmanship or *disegno*. This belief that the drawing of a painting was of greater importance than its coloring is repeated throughout the book. He contributed toward the preference for drawing over color that was to be an important tenet of academic instruction in later times.

Another frequently mentioned criterion of great art for Vasari was that the artwork should clearly and accurately express and communicate an emotional state from the artist to the viewer. This idea of the importance of the artist's communicating a clear message was a topic taken up again most notably by Tolstoy in the nineteenth century. One frequently cited example of this criterion comes from the life of Correggio, in which Vasari describes a smiling angel in *The Madonna of St. Jerome*, "who smiles so naturally that all who look at it are moved to smile and no one, however melancholy, can see it without being gladdened."[9]

Vasari was not without his faults as an accurate historian. Many of his dates and much biographical information were based on rumor and misinformation, but his consciousness of quality has never been seriously questioned. For example, he includes Titian in his later edition of the lives, as a member of the artists of the third period, praising his lively quality in spite of his emphasis on color over design. His intuitive feelings about the work could not be fully suppressed by his theories or his Tuscan heritage. He is, in fact, unusually moderate in his appraisal of individuals who were his enemies, for example, Benvenuto Cellini.

Jakob Rosenberg, in his book *On Quality in Art*, believed that Vasari made a mistake in associating the highest achievement in art with one master—Michelangelo—and that he let in the seeds for dogmatism in classical theory.[10] Not only was Vasari wrong in his devaluation of medieval art but Rosenberg believes it led to problems in assessing the artistic merits of artists before Giotto. The narrow focus on Michelangelo as the ultimate artist leads logically to the possibility of slavishly copying the master rather than determining new ways of

creating art. If beauty is conceived of as the art of one artist, can a hardening and codification of classicism be far ahead? Vasari must ultimately be understood as not only a product of his time but a close and adoring friend of Michelangelo's. It is understandable that Michelangelo would be so praised.

His praise of Michelangelo's genius did not inhibit his admiration for Raphael or, from an earlier period, Donatello. Both Vasari's commitment to grace and verisimilitude and his commitment to Paulo Giovioto would naturally predispose him to create a history of Renaissance artists critical of medieval art. One must consider the achievements of Vasari as qualified by the choices that he could and did make, and how those decisions or judgments related to the common practices of his time. The fact that he made errors in the dates of birth or deaths of artists, or errors in description of their art works, is understandable considering that he had little prior research to rely on and that viewing art at this time was a laborious and almost impossible task to accomplish. If one looks at Vasari's book contextually, the work is surprisingly undogmatic; rules are given but sometimes not followed. The transcendent element of art, its association with divine nature and consciousness is emphasized throughout.

Although Vasari looks at artworks with eyes conditioned to like and dislike certain qualities of art, for example, drawing over color, he puts aside this prejudice and praises Titian despite the artist's emphasis on color over design. Because he was not a theorist, or interested in explaining in depth his own personal experiences with art, one can only infer his meaning from his most enthusiastic evaluations. For example, in his description of Leonardo's *Last Supper* he describes the work as "wondrous and most beautiful, that it was a source of wonder."[11]

Perhaps the best evidence of Vasari's own aesthetic response to a work of art comes with his assessment of *The Last Judgment* by Michelangelo. He states:

> And besides every beautiful detail, it is extraordinary to see such a work painted and executed so harmoniously that it seems to have been done in a single day (a sense of wholeness and a consumatory effect) and with the type of finish that no illuminator could ever have achieved; to tell the truth, the multitude of figures, and the magnificence and grandeur of the work are 'indescribable,' for it is full of all the possible human emotions, all of which have been wonderfully expressed.[12]

He later goes on to connect Michelangelo with divinity and ultimate knowledge. Although one could be disappointed that Vasari seems incapable of or uninterested in explaining his responses more completely, his writings on the arts not only imply an aesthetic response, but strongly support the conception of intuition or nonmediated thought over rational thought in the creation of the highest forms of art. He also emphasized throughout his book that art is associated with an objective, transcendent, and divine "Grace." Obviously, these ideas stand in sharp contrast with current Post-modern theory, in which art is only about subjective experience, symbolization, or rhetoric. Without a consideration and inclusion of objective theories of art, present art education programs will present a slanted understanding of art, heavily emphasizing its subjectivity and ignoring a tradition that is essential to a fuller understanding of the subject.

The Image of the Artist as Rebel and Social Critic

With regard to the image of the artist, Vasari believed that the view of artists became associated with melancholic personalities. He also helped implant in future generations the idea that artists possessed divine mania and were often eccentric and difficult personalities that might be indifferent to the world around them. A more radical interpretation of these characteristics came with the Romantic movement of the eighteenth and nineteenth centuries. Artists began to be considered alienated and isolated from mainstream culture and society. Charles Baudelaire, in particular, developed the idea of the artist as rebel when he described the characteristics of the modern artist.[1] Artists, he believed, are by their nature alienated from society because they are destined to pursue perfection or beauty in a world that is imperfect. They are hypersensitive individuals cursed by their genius. He calls them "genius irritable," because while pursuing beauty, they overreact to the injustices of the world.[2] To be true to the artistic vision, the artist must consciously separate from society and become an impassive or stoic and distant observer, "refusing to be elbowed by the crowd, and running off to the extreme easterly point, when the fireworks are being lit off in the west."[3] Thus, the image of the "irritable genius" becomes one of a romantic hero whose nonchalance becomes even more studied and self-conscious. He is no longer primarily an interpreter of divinity in nature but rather an outsider who interprets a world composed of artifice as well as divinity.

In the twentieth century, Clement Greenberg further developed the idea of the rebel artist when he described the artist as a new kind of dandy, one that was stoic and courageous but also arrogant and street-smart.[4] Greenberg's ideal artist is even more materialistic in conception,

requiring inspiration from the materials of painting itself and the Modernist tradition, rather than through a divine nature or the use of a spiritual imagination.[5] One could also argue that Greenberg's materialism has many of the qualities of a transcendent spirituality, but it is definitely determinist and materially oriented.

A negative view of Clement Greenberg continues in Post-modern art criticism and commentary, based primarily on a reaction to his formalism and aestheticism; it is odd, however, that his view of the artist has been largely appropriated. The Post-modern artist is still perceived to be, as the Romantic poet and critic Scheller stated, "never bourgeois and respectable."[6] There are, of course, differences in the two conceptions. Greenberg's arrogant artist was inwardly and aesthetically focused, whereas the Post-modern artist is predominantly outwardly focused and concerned with contributing to the social and artistic rather than the aesthetic dialogue of the time. The Post-modern artist is even more materialistic than Greenberg's example but has a diminished role in the process of artistic creation and consumption. Instead of being the creator of original work, the prime mover of the artistic process, the contemporary Post-modern artist is perceived to be merely an arranger of pre-existent images or signs. The pursuit of extra-aesthetic goods and objectives is considered more important than interest in the aesthetics of creation. The image of the Post-modern artist as a trickster or con man may be predetermined in part by Vasari's linking of genius and divinity. Since Post-modern artists cannot hope to offer an objective or transcendent truth, they become in fact fraudulent authorities, capable of orchestrating the game of art but not its original context.

The current image of the Post-modern artist as a rebel is of course a fallacy. It is doubtful that this inherently romantic conception has ever adequately expressed the real role of the artist at any period. But in particular, in today's world, art is rarely censored for its content; controversial art is often shown regardless of whether it offends the sensibilities of the middle class. In fact, it often seems that the more offensive it becomes to the sensibilities of the bourgeoisie, the more lucrative are the rewards for the artist and the gallery. The value of this art is contained in its social or antisocial message, not in the aesthetic image. The offense is the content in this case. Ultimately, the Post-modern artist relies on the established art world for collaboration, promotion, and profit. The hypocrisy of this position is plain, and an elaboration of the hypocrisy is needed in art education. The role of the artist in Post-modern times is confused and problematic.

6

Lomazzo and Bellori and the Hardening of the Term of Imitation

Aesthetic theory, during the Mannerist period (1560–1600), went through a transformation. Aristotle's *Poetics* was finally available to Renaissance scholars in translation from the original Greek. With regard to the visual arts, the *Poetics* reinforced a renewed sense of classicism that ultimately found both the distortion and experimentations of Mannerism and the naturalistic style of Caravaggio and his followers threatening. Because the visual arts were also sister arts with poetry, they too could express the universal and ideal. Aristotle emphasized the need for artists to depict man in a more conservative, classical tradition. Two other developments, in the beginning of the sixteenth century, affected the direction that art theory and specifically Classicism would follow: Antiquarianism and Mythography. The idea that the artist must be trained to correctly depict mythological and religious figures and episodes was not a new concept and had been included in *De Pitura*. Alberti stated, "It is not suitable for Venus or Minerva to be dressed in a military cloak."[1] For iconographic truth or correctness to be disseminated systematically to both painters and sculptors, iconographic manuals needed to be published. One significant publication was Lilio Gregorio Giraldi's *History of the Gods* (1558), which gave the correct ideal representations of mythological figures.

The interest in classical mythology was enhanced by the fact that ancient classical art was increasingly unearthed during the sixteenth through eighteenth centuries. The scholars or Antiquarians who studied and described these works became increasingly important as art theorists and critics. Unfortunately with regard to rules and dogmatism, it is far easier to forget their subtle sense and apply them crudely

than to remember the subtlety and apply them finely. If rules for art are interpreted absolutely, when a decision is made to consider only one side of a dichotomy, whether that be the empirical or the ideal, the realistic or the transcendent, the logical or the intuitive, the end result is that the creative process suffers. The later theorists of classicism as a whole failed to allow this dichotomy to exist and chose to find the study of antiquity incompatible with the study of the empirical world. Lomazzo and Bellori in particular represent this development of dogmatism in classical art theory, although Vasari had established that the study of ancient sculpture was one of the factors that had made high Renaissance possible. These later theorists established a new tradition and a new reliance on classical sculpture as the primary source for the ideal in art. This idea finds its final culmination in the writings of Johann Winckelman and George Hegel.

Giovanni Paolo Lomazzo (1538–1600) had been a minor painter who became an Antiquarian after going blind at the age of 33. In his two major works on art theory, *The Treatise on the Art of Painting* (1584) and *The Idea of the Temple of Painting* (1590), he established a system for correctly depicting classical subjects. *The Treatise on the Art of Painting* was translated into French and English and became widely influential until the nineteenth century. It is composed of seven books which deal with the theory of proportion, motion, color, light and shade, linear perspective, the practice of painting, and iconography. Lomazzo's contribution lies in the fact that he took an existing and disparate classical theory and systematized its ideals into practical tenets. He associated nine types of emotions, such as devotion or faithfulness, with specific body movements and gestures. Using a compilation of antiquarian knowledge and astrological mysticism, he associated, for example, melancholy with the Earth. He stated, "The movement of melancholy is dangling, heavy, and restrained because melancholy is composed of the element of earth which, itself tending downward, is heavy and compact."[2]

In book 6, concerning the practice of painting, he gave instruction on how to paint specific "types" of history painting, or those paintings where the subject is mythological or religious. Concerning the correct way to represent a naval battle, he stated, "the painter should not omit the defeated pleading for mercy, their hands crossed on their chests, nor should the boats, with corpses cast into the water, be missing."[3]

In *Idea* (1590), Lomazzo organized his treatise on the number seven, describing seven columns of an allegorical temple of painting. Each column represents the seven parts of painting and is associated

with a specific artist who exemplified that quality. Thus, light is associated with Leonardo, proportion with Michelangelo, perspective with Mantegna, and color with Titian.[4]

Alberti and most notably Vasari assumed there was one ideal beauty; for Lomazzo the emphasis is on types of ideal beauty. He believed that artists could achieve perfection by emphasizing any one of seven mental qualities. He also indicated that perfection could vary according to types within these categories. For example, in book 2 of *The Treatise on Proportion*, he notes that there is more than one ideal proportion of the figure. A shifting of emphasis in his writing marks a change in Italian classical theory from the emphasis on one inevitable beauty to the belief that beauty and perfection exist in different types. As his successor, Bellori, stated nearly one hundred years later in 1672, "We appreciate the soft Venus and the huntress Diana, both are ideal."[5]

Lomazzo's systematization of classical theory was the logical development of emerging ideas on classical decorum. However, his theory was not visual, nor did it capture the spirit or concerns of earlier theorists concerning the uniqueness of visual representation. The same problem can be seen with Post-modern art theory; it also often fails to consider the visual as a unique form of expression and representation. When a visual distinction is not made or considered, a myopic understanding of the visual arts often occurs.

Unlike Alberti, Lomazzo could see no problem in expressing any emotion with an appropriate gesture or arrangement of composition. The concept of describing types of ideal beauty while seemingly expanding on the concept of one ideal beauty had the opposite effect, in fact limiting what could be considered appropriate or beautiful, since the types were themselves literally described gestures or arrangements originating from classical masterpieces of the past. One could speculate that the study of nature was discouraged by Lomazzo because its natural variety would no doubt conflict with these examples. The concerns for the complexity of visual representation found in Alberti and implied in Vasari is absent in Lomazzo. For this reason Lomazzo is the least visual of the Italian classical theorists, and the one whose ideas seem most related to Modern and Post-modern Symbolist theory, where art is ultimately equated with literary representation, rhetoric, and propaganda.

Many individuals contributed to the development of aesthetic theory during the Renaissance and later. In the late fifteenth century, Leonardo Da Vinci had expanded Alberti's ideas on art and had added his own practical orientation. Disputes over the relative value of the

arts, known as "Paragon Literature," were also common throughout the Renaissance.

In 1567, Vincenzio Danti emphasized the importance of the *Poetics* for the visual arts and advocated the imitation of Michelangelo. Armenini (1540–1609) emphasized the style of Raphael and the validity of rules to painting.[6] There were also individuals such as Pieto Aretino (1492–1556) who praised originality and the sensual qualities of painting, and believed that young painters should not follow the style of any master.[7]

A new Romanticism in thought began to be developed by a group of theorists active around 1600. Giordano Bruno (1548–1600) emphasized not only originality and a break with tradition, but most notably the concept of a subjective beauty. His theory, expressed in *De gl'Eroici Furori*, translated as the *Heroic Enthusiasts*, could be thought of as more representative of a Romantic sensibility than a classical one. He was above all else a believer in individual self-expression, a very modern concept in an age when originality was synonymous with the ability to copy the ideal found in a pre-existing nature. Bruno believed the artist's purpose was to create something that had never existed before.

He described beauty in Post-modern terms as relativistic and subjective with three characteristics. These were that there was no universal beauty which affects all men alike, that beauty was based on the disposition of the beholder, and that it was not absolute.[8] He stated, "Poetry is not born of rules, rules however, are derived from poetry, and therefore there are as many correct rules as there are kinds of and species of true poets."[9] Bruno believed that the essence of beauty was ultimately undefinable and indescribable, and that a treatise on art would be useless. His ideas on arts and beauty seemed antithetical to writers such as Lomazzo, and in fact lay the groundwork for future Romantic theory and the idea of the creative imagination.

Bruno's belief that beauty was more associated with feelings of pleasure than with ideas, that there was a conflict between the realization of one's feeling expressed in the work of art and an adherence to classical ideas, establishes him as an early supporter of the concept of an aesthetic experience, despite his relativist beliefs. Art criticism was for Bruno an afterthought, an inadequate rational explanation of an indescribable creative action. He was ultimately concerned with the creative imagination and the uniqueness of the individual, two ideas unrelated to Post-modernism.

Alberti's sense of optimism, that science and rational thought could explain the nature of the arts or perfection in the arts, was increasingly

challenged by the start of the seventeenth century. Early scientists such as Francis Bacon and Galileo saw essential differences between art and science, and linked art with the imagination and not rational thinking. The related idea that artists should follow rules for art was also under dispute. Federico Zuccari (1540–1609), the president of the Academy of Design in Rome, rejected all rules because he thought that they inhibited imagination and creative powers.[10]

Giovanni Bellori (1615–1696) was an Antiquarian, like his stepuncle Francesco Angeloni, and a connoisseur associated with the conservative Academy of Saint Luke. Bellori represented a conservative return to an earlier form of classicism that was exemplified by the art of Raphael.

The title of Bellori's most famous work, *The Lives of Modern Painters, Sculptors and Architects* (1672) suggests a work similar to Vasari's, but it has a different scope entirely. Instead of attempting to include all Italian artists of the Renaissance, he described twelve prominent artists from Italy and other European countries. Bellori, like Lomazzo, emphasized theory over biography, and the artists given represented types of ideal artists and their art. Like the Mannerist theorist, Bellori believed that beauty was diverse and could have many distinct forms. Thus beauty was synonymous with the correct nature of a subject.

Although Bellori allows for different types of beauty and even notes the attributes of different schools of artists, such as Venetian, Lombard, Tuscan, and Bolognese, he contradicts this idea of equality by promoting the graceful qualities of Raphael as supreme. With Bellori there is a shift away from the energy and dynamic qualities of Michelangelo that had made Mannerism possible. Among contemporary painters, he preferred Poussin and Annibale Carracci.

Bellori believed that the art of his time had lost its direction. Mannerist art had lost its connection with nature and instead relied on a slavish copying of previous masters. The revolutionary art of Michelangelo Caravaggio presented a different problem in that it exemplified an art that had failed to select from observed nature its ideal or beautiful aspects. For Bellori, the more conservative art of Annibale Carracci was a return to an ideal form of beauty.

Bellori represents the culmination of the problem of considering art from a Neoplatonic viewpoint. Erwin Panofsky, in *Idea: A Concept in Art Theory*, points out the contradiction in being a Neoplatonic art theorist: it is incompatible with the Renaissance artist's need for the sensual experience of nature. Many theorists of the Renaissance and later, like Bellori and Lomazzo, and to a much lesser extent Vasari,

were influenced by Neoplatonic ideas, but none, with the possible exception of Lomazzo, omitted the need to study nature firsthand.

Bellori used many Neoplatonic references in his introduction to *The Lives* but quickly reverted to the necessity for the study of nature (as well as the study of ancient sculpture). According to Bellori, artists must find ideal beauty in the natural world by the process of introspection rather than systematically averaging ideal examples as Alberti had suggested. One reason for this position was that he was not only attacking Mannerism and its policy of omitting the study of nature in favor of masterpieces of the past but he was again expressing his Neoplatonic reservation over the possibility of any ideal coming from the averaging of empirical bodies. His idea that beauty or the good can be found by introspection appears to foreshadow modern ideas about psychoanalysis and the arts. He suggests that the artist needs to blend reason with intuition if great art is to be produced. This union of the mind is suggested in Bellori's understanding of the term "introspection."

Bellori could not eliminate nature as a source of art even though he denigrated its corruption and lack of perfection, because he was aware of the fact that the artist could not escape a reliance on the perceptual world. Even if one believed that divinely inspired artists relied on a mystical communication with God and not the observation of nature in creating their art, their own works of art existed (for study and evaluation) in a physical and not a spiritual world.

Bellori believed that these masterpieces were as close as one could get to ideal mimesis and should be copied and studied. But the very study of these material objects brings us back to the physical and sensual domain, the world of matter and nature rather then a mystical or spiritual conception of transference.

Bellori believed that artists needed to study nature but strongly emphasized supplementing this study with masterpieces of ancient sculpture and great painting. He believed that young artists needed these examples in order to develop the discrimination or introspection necessary to select beauty from nature. Bellori's concern was that artists usually did not develop this discrimination naturally. This led to the emphasis on copying and studying ancient sculptures and great paintings especially of the Roman experience. Bellori sided with the French wing of the Academy of St. Luke and remained close friends with Poussin, who shared his enthusiasm for both Raphael and the Carraccis. He became an honorary member of the Royal French Academy of Painting and Sculpture in 1689 and was in many ways its original primary theorist.

Although Bellori represents a hardening of the rules for classical art, he differed in one way from Lomazzo. He recognized that the visual arts were often distinct from literature. In his descriptions of painting he not only emphasized the allegorical correctness of the figures, its literal narrative, but he also occasionally pointed out "formal" or visual elements. For example, he noted that the color of a masonry wall had been developed to serve as a foil for the figures set against it.[11]

Bellori may have been dogmatic in his estimation of Caravaggio and others, but his Antiquarian training mandated that he consider the physicalness of the visual arts in a way that conflicted with a total or analogous literal interpretation. In this sense, Bellori's art theory, although confused and sometimes contradictory, was still a visual art theory, giving evidence of a return to the visual and a separation from literary theory. Thus the instruction in art taught at the French Academy and others that were influenced by Bellori's ideas may well have emphasized copying the work of ideal masters, but it was essentially a visual mastering requiring hours of studio discipline. This seems in sharp contrast to many M.F.A. programs currently at American universities where the fundamental drawing instruction is considered unimportant and the ideas or meaning implied in a student's work is exclusively emphasized.

7

The French Academy

Charles Le Brun (1619–1690) was a co-founder of the French Academy (1648) and its first director. In his role as director, he delivered discourses on art to members, was in charge of the royal collection, and was director of the royal tapestry and furniture factory. He was also a practicing artist. He was not an intellectual, or an Antiquarian like Bellori, but he shared with him and the royal patron of archaeology, co-founder Jean-Baptiste Colbert, a conservative taste for Raphael, the Bolognese School, and Poussin. As we have seen, it was this form of classicism that the early academy was to endorse. Another influence in the French "Grand Style" was Nicolas Poussin (1594–1665). He was born in Normandy but had spent almost his entire career in Rome. Poussin never wrote a treatise on art, as his friend Bellori did, but he did write a series of letters expressing his views on art. He emphasized the need to show emotions clearly and the related idea that each figure should express a single emotion. This was to be accomplished by gestures, movements, and, to a lesser extent, facial expressions.[1]

There is a mistaken tendency to think of the French Academy during the seventeenth century and later, as connected with the Rationalist movement in philosophy. The reality was that the influence of Descartes's clear and distinct ideas was minimal at best.

The artists of the academy might listen to conferences expressing the need for clarity and logic in their work but they would inevitably go back to their studios and paint a variety of interpretations of classicism. The art of the period of Le Brun was determined, not so much from a need for greater rationality, but a need for a style that would be fitting for the grandeur of the powerful king Louis XIV. It was an art

of magnificence that had little to do with rationality but featured awe, bravura, and theatricality.[2]

Seventeenth-century French aesthetics was increasingly influenced by other forces besides Cartesianism. The weakening of the authority of Christianity brought a renewed interest in Epicureanism and an interest in the arts as a source of pleasure rather than moral instruction. The Rococo style in art was the eventual result of this interest.

Many seventeenth- and eighteenth-century French theorists and artists doubted that art could be explained by reason. The idea that rational rules could determine great art, or that reason could explain the pleasure that some art produced was insufficient for them. The poet Fontanelle expressed this skepticism when he stated, "*I compose and then I think*, and to the shame of reason this is what happens most often; thus I should not be surprised if it were found that I did not follow my own rules."[3]

The theorist Jean-Baptiste Du Bos (1670–1742) continued this orientation by emphasizing the distinction between sentiment or emotion and reason. Reasoning, according to Du Bos, was used only to explain an individual's prior judgment that is based on sentiment. Art, therefore, affects mankind regardless of the rules; it is a product of chance and genius and not of academic instruction. The seventeenth and eighteenth centuries at the academy were, by and large, centuries of fertile disputes among its members regarding a variety of artistic topics and were not reactionary or complacent. For example, there were lively discussions in the conferences of the academy concerning the relative value of ancient art versus modern, as well as discussions over the importance of color in relation to drawing and design. A significant hardening of the dogma of the academy came much later in the 1750s as a result of the influence of the conservative amateur Comte de Caylus. His contribution to the academy was in part due to his awareness of the growing public interest in the visual arts and his establishment of bi-annual salon shows starting in 1745. These shows were held in the Louvre and were open to the public. He also called for a renewed interest and veneration of the antique and founded a salon prize, the Prix d'Expression, to help reward artists who painted in this style. Along with Johann Winckelmann, he helped create the conditions necessary for the Neoclassical movement.

In the second half of the seventeenth century and the early eighteenth century, many French intellectuals interested in the arts subscribed to Blaise Pascal's notion of "je ne sais quoi." This phrase expressed the idea that the pleasure that one received from the arts was

due, in part, to an "indefinable quality." Although reason was necessary for understanding the arts, it was not sufficient in explaining this pleasure.

This concept of "je ne sais quoi" has also suffered in Post-modern theory. In current Post-modernism a theorist or teacher taking a position emphasizing the indefinability of artistic quality seems both passé and irresponsible. But Pascal's notion of "je ne sais quoi" is more adequately considered a proclamation of the uniqueness of aesthetic experience and a desire to prevent dogmatic thinking in the arts.

8

Roger De Piles

Roger De Piles (1635–1709) was a French diplomat, tutor, art theorist, amateur, and art critic. His first work on the arts was his translation of Du Fresnoy's poem *De Arte Graphica*, which expressed the ideals of classicism in verse form. Later, in 1709, he published his most important and original theoretical work, *Cour de Peinture par Principle avec une Balance des Peintres* (The Principles of Painting with a Balance of Painters). This book contained the essence of his theory: his assertion that color, light, and shade had a value equal with drawing, and his ideas on the uniqueness of the visual qualities of painting. It is in the work of De Piles that the "je ne sais quoi" quality of the visual arts— referred to by Pascal and others—and its effect on the perceiver receive more mature consideration and further development. De Piles's insistence on the separation of visual and literary criticism made him a forerunner of modern visual art criticism.

His aesthetic theory had three purposes: to liberate the theory of painting from literary theory; to emphasize that visual interest in a painting or artwork is independent of an intellectual, moral, or religious interest in the picture's subject matter; and to change our way of looking at pictures to one more closely associated with the way we look at nature.[1]

This last point makes an important break with the manner in which in the seventeenth century the French Academy had proposed that a work of art should be viewed. According to Poussin and later André Félibien, a picture should be "read." This means that the viewer should look at it in stages, concentrating on groupings of figures that would describe episodes of a story. De Piles disagreed with this episodic way of looking at art. He believed that a visual work

of art should be perceived immediately and spontaneously as a physical unity.

It was De Piles's interest in the shapes and colors of artworks that separated him from classical theorists like Félibien, Poussin, and Charles Le Brun who considered painting to be similar to poetry in serving the primary purpose of narrating a story. Ignoring the differences between the two media, these academic theorists emphasized the artist's concern with the unity of a painting's subject rather than the unity of its objects, forms, and colors. Those formal aspects of painting were, of course, acknowledged, but they were deemed merely part of the artist's craft and less important than the appropriateness and clarity of the subject represented. Before beginning to paint, the properly trained artist should concentrate on the suitability of the subject. De Piles, by contrast, believed that this was only one side of an artist's preparation and that thought should also be given to the painting as a visual image, a pleasing illusion of nature.[2] De Piles expressed this emphasis on the visual when he said that the end of painting "is not so much to convince the understanding, but to deceive the eye."[3]

Although De Piles can be said to have been the first art theorist to place the unity of the object above the unity of the subject, he was still a classicist in the tradition of Bellori, Poussin, and Le Brun. He admired the art of Raphael and disliked the art of Caravaggio and his followers. He believed in the moral benefits of ideal representation and held realism in gesture and approach to be indicative of an artist's lack of imagination or skill in selecting beautiful forms from nature. But he was most importantly a theorist who described and placed a great deal of importance on the concept of a visual aesthetic experience.

De Piles agreed with Pascal that the experience of aesthetic pleasure could not be defined; but, unlike Pascal and others, he believed that the elements of immediacy, surprise, and effectiveness could help explain this experience.[4] In his "Principles of Painting," he defines enthusiasm as an elevated state of mind that spectators achieve when they appreciate the artist's invention and feel the sublime effects of the work's subject matter. De Piles's notion of enthusiasm serves as his explanation of aesthetic experience. It is important to note that, according to De Piles, the spectator is able to receive the full effect of the subject matter only because of a painting's sensuous appeal.

De Piles's writings on art are characterized by his respect for the uniqueness of painting as an art form. Believing painting to be an imitation of nature and, as such, a combination of artificial conventions for the purpose of deceiving the viewer, he states, "Painting, in general,

is but daubing; its essence lies in deceiving, and the greatest deceiver is the best painter."[5] De Piles's interpretation of the classical ideal was more realistic than that of many others because it most frequently stressed the criterion of convincing realism. Since color is an essential aspect of visual reality, it is also an essential part of painting. For De Piles, color was the soul of painting and drawing its body. He states, "As an artist, I would prefer Raphael, but as a painter, Titian is greater."[6] In particular, he defended Rubens's art and use of color against those conservative members of the academy who valued drawing exclusively. His description of Rubens's *Fall of the Damned* is glowing in its admiration for the skillful drawing, the color, and the use of masses of light and shadows.[7] In his *Abridgment of the Lives of Painters* (1699) he is critical even of Poussin, stating that because the painter had "looked too much at the antique his paintings often looked like stone themselves and lacked something human."[8]

De Piles was the first Frenchman to purchase and exhibit a painting by Rembrandt, whom he admired for his naturalism despite his lack of classical decorum and idealization. De Piles held that painters must observe nature but seek a union of two truths: the simple truth of everyday nature and that of ideal nature. This combination would result in perfect truth.[9] De Piles was also the first classical theorist to consider landscape an important subject matter, historical painting having previously been held to be of primary importance.

De Piles's *Balance of Painters* contains a sampling of his critical judgments of prominent painters as well as his advice to critics. "But I must give notice," he states, "that in order to criticize judiciously, one must have a perfect knowledge of all the parts of a piece of painting, and of the reasons which make the whole good; for many judge a picture only by the part they like, and make no account of these other parts which either they do no understand, or do not relish."[10] Critics must be open to an unprejudiced impression of the painting. They should search for the reasons for the effect (of enthusiasm), and only then should they consider whether or not the rules have been observed.[11] Critics are also encouraged to present good arguments for their judgments, whether positive or negative. De Piles further agrees that we need to study as many great masters as possible to derive all the standards of art and that we should evaluate art by comparisons among artists.[12]

In *Balance*, De Piles compiled, to please himself alone, a list of major contemporary and past artists whose work he analyzed according to four components of painting: composition, drawing, color, and

expression. In this scheme, an artist could receive a score of 0 to 19 on each of these components, with 20 being perfection. He gives high scores to baroque masters of his century. Rubens receives a 65, Van Dyck 55, and even Rembrandt scores a 50, despite a score of only 6 in drawing. Although De Piles collected Rembrandt's drawings, he could not score him higher in this category because of the absence of ideal truth in his figures. Even an artist like Le Brun scored a surprisingly high 65, with a 16 in expression (of classical ideals). It is clear that history did not confirm that last evaluation, nor the low rating of fifteenth-century masters such as Bellini (27). Caravaggio scores only 28, with a 0 in expression and a 6 in drawing. Thus, De Piles concurred with the academicians in their preference for the Carracci over Caravaggio and their devaluation of Michelangelo as compared to Raphael. His only clear difference with them lies in his favoring color and artists who emphasized color in their work, for example, Rubens and Titian.

What are we to make of this seeming contradiction in a man who collected Rembrandt's drawings but evaluated them as poor? We must consider De Piles within his historical setting, his period, and place. He was still a classical theorist living at a time when individual experimentation and originality as we know it today were largely denigrated. Instead, the emphasis was on ethical reasoning, classical standards of perfection, and idealized nature as the means to gain insight into God and the ideal. De Piles would not have been able to break completely with the pervasive norms of his time.

Despite this, he became the major influence on modern visual art criticism because he had initiated the concept of the separation of the art object from the art subject. He also described the proper manner of evaluating art as consisting of looking at art with an open mind, having an aesthetic experience with it, and then explaining the nature of that experience. De Piles's acceptance of the greatness of artists from countries other than France and Italy, as well as his collecting and exhibiting Rembrandt's work, is evidence of less dogmatic thinking and a broader range of taste and appreciation than were displayed by many of his contemporaries. His ideas on art stress the visual and the aesthetic and, as such, represent a point in the evolution of art theory, classical art theory in particular, when the aesthetic becomes less inferred and more openly described.

9

The Evolution to Romanticism

The evolution in art theory from classicism to Romanticism was a gradual one. Classicism, as we have seen, emphasized reason as a means of gaining insight into the ideal. The overall emphasis in classicism is that art is about reason or rational knowledge and the instruction of moral precepts and not about personal feeling and emotions. Classical theory also emphasized a universal beauty that was objective and was attainable both in practice and appreciation through the use of a reasoned contemplation. There was an equal emphasis on the concept of clarity with regard to the depiction of subject matter. As an artistic movement, it opposed the naturalistic or any concept of art that deviated from the notion of ideal mimesis. Ultimately it was at its core concerned with the transcendent or religious, and sought, at least in theory, to express the concept of God's universal beauty. It did not seek to describe the meaning of one's individual life since that seemed of little importance within the greater scope of objective reality.

Classicism had as its primary rule the preservation and ennobling of nature in accordance with historical and iconographic truth, or as it is otherwise known, decorum. Art's purpose was to instruct man through decorum and grace, and art was only incidentally intended to please the senses. But these tenets of classicism which appear to ignore the sensual experience of art were seldom adopted. As has been noted previously, many of the prominent classical art theorists, Alberti and Vasari in particular, seem to allow for variation in the adoption of classical rules and seem to place the aesthetic and visual effect over their own preconceived prescriptions for excellence.

The Romantic period, emerging in full force in the nineteenth century, broke through the pretext that art was primarily instructive and

not sensual and aesthetic. However, this was a slow and gradual process that depended on the strengthening of certain concepts of personal freedom, gratification of the self, and a belief that pleasure could be both revelatory and beneficial, and was not the domain of the sinful. This process was accelerated by the questioning of pre-existent theory that characterized the period known as the Enlightenment.

Intellectuals of the Enlightenment, like Pascal or Du Bos, as well as such late Renaissance theorists as Bruno, had undermined many of the tenets of classicism. They pointed out the empirical reality of many forms of beauty and a subjective appreciation of the arts. They had also undermined the concept of reason, associating the creation and appreciation of art with the emotions or with "je ne sais quoi" as opposed to rational thought.

The concept of the artist as a distinct personality and the related concept of genius popularized during the late Renaissance also weakened the emphasis on rules and increased the value placed on the use of the imagination of the artist.

One of the chief catalysts for this evolution was the contribution of British psychological empiricism during the seventeenth and eighteenth centuries. Empiricism was concerned with the scientific study of matter and was indifferent to the concept of a spiritual reality. It was a philosophic movement that questioned whether it was possible to know whether a spiritual reality even existed. One could believe in God but this God had created the universe and then allowed people to direct their own actions. Thomas Hobbes had described in his *Leviathan* (1651) a world where nothing existed but matter and even human behavior was governed by self-interest and not God's will or direction. John Locke had further separated man from God by denying the truth of the concept of innate ideas.

Humans, according to Locke, did not possess ideas at birth that would direct their moral behavior. Babies were born with a "blank slate" and acquired all knowledge through their experiences in the world. A child did not know what was right or wrong and his moral instruction on these matters came through the instruction given to them by their parents or elders and not through an innate idea or "communication" given by God. This new emphasis on materialism undermined the classical idea that art was intended primarily to instruct mankind.

Empiricism, as the concept pertains to the arts, was concerned with the pleasure one gets from the experience of nature and art. To understand excellence in art one should study the psychological causes and

effects of art. Inherent in the concept of empiricism is a need for empirical validation and an equal distrust for prior rules that would govern excellence in art.

Empiricism ultimately supported the idea that judgments in the arts were subjective. David Hume acknowledged, "Each mind perceives a different beauty that it is not a quality of things themselves but exists in the mind."[1] He was to qualify this subjectivism in his famous essay, *Of a Standard of Taste*, by concluding that there would be a consensus regarding artistic judgment if everyone had the facilities and experience necessary for good taste. This probably would not be possible because of the limitation of taste in individuals; however, everyone could improve his or her ability to appreciate art by consulting individuals with good taste and looking at art repeatedly and reflectively. In spite of Hume's speculation, the empirical study of man's artistic judgments, even the judgments of those educated in the arts, reveals vast differences in their likes and dislikes.

Empiricism also emphasized a renewed interest in the role of the imagination in determining how we perceive the physical world. Locke believed it was the imagination that enabled man to imagine unicorns, monsters, or any nonexistent creature. Hume believed that the faculty of the imagination or the "fancy" was the source of all our knowledge and our ability to reason about the world. This emphasis on the imagination reinforced the idea that the artist's imagination was an important source for the production of art and an important aspect of the creative experience.

British empiricism was also interested in the role of the emotions or passions in determining human behavior. In fact, Hume's skepticism over the validity of knowledge and his emphasis on the irrationality of man helped Kant formulate his new metaphysics. In any event the failure of British empiricism to prove that the primary properties of matter could be perceived led to the supremacy of German Idealism in the nineteenth century. British materialism had its effect on aesthetic theory, emphasizing pleasure and physical experience, but it must be noted that the transcendental aspects of this experience were never lost.

David Hume wrote of a "standard of taste" and accepted the concept that most individuals could reach this standard. The concept that each person's experience with art is absolutely subjective, that one cannot hope to understand another's experiences, was not considered by Hume. Humans were social creatures to Hume, and by their natures possessed shared faculties and abilities to understand one another. The

British Idealist philosopher the third Earl of Shaftesbury most influenced continental and later art theorists of the late eighteenth century such as Johann Winckelmann, Sir Joshua Reynolds, and Denis Diderot. Although tutored by John Locke, he could never accept Locke's argument against innate ideas, nor the relativism of materialism. Instead, his philosophy is both Idealistic and Platonic. Shaftesbury was a believer in the concept of aesthetic experience; he believed that through this experience mankind could mirror the creative power of God himself. He believed, in particular, that this experience would produce a spiritual harmony that would be revealed to mankind intuitively and not rationally.

10

Johann J. Winckelmann

Johann J. Winckelmann (1717–1768) was an antiquarian, art historian, and author of *History of Ancient Art* (1764). The sources of Winckelmann's ideas on art are Bellori and Shaftesbury, and he represents a conservative return to a Greek classical standard in the visual arts. He characterized that standard as a noble simplicity and a quiet grandeur.[1] Unfortunately, he based his ideas on faulty data. The statues on which he based these characteristics were not classical Greek, but were Roman copies that were not characteristic of much of ancient Greek art. David Irwin points out, in *Winckelmann, Writings on Art*, that the turning point in the assessment of Greek art came after Winckelmann's lifetime with the importation, in 1808, of the Elgin Marbles and the revelation of the authentic realism of Phidias and the classical period.[2]

Winckelmann believed that the Greek ideal stressed simplicity and calmness and was characterized with a generalized anatomy and an omitting of facial features. He also seemed to be unaware of the Hellenistic Greek emphasis on naturalism. His aesthetic ideal was strongly influenced by the decoration on Greek vases, the composition of Roman sarcophagi and relief panels and the austerities of the Greek order at Paestum. In his descriptions of paintings he is more concerned with a simple composition of lines than with mass, shading, or color.[3]

A good artist, according to Winckelmann, followed rules and understood decorum.[4] Like Bellori, he saw in art, particularly sculpture, the opportunity to overcome the imperfections of matter. The role of art was nobler than mere pleasure because it existed for the purpose of instruction. In its highest forms it required an educated and sensitive audience in order to be understood. Winckelmann interpreted art in

terms of its moral content. For example, the *Laocoön* was interpreted as an archetype of stoic virtue.

He disliked Baroque painting and sculpture and accused Bernini of lacking decorum and knowledge of ancient customs and dress. History painting was his only accepted subject; he ridiculed landscape, still life and genre subjects in painting. The only contemporary painter he praised was Raphael Mengs, whose style fit into his conceptions of the beautiful. Mengs was using allegory appropriately, as the ancients did, and he wanted more painters of his time to return to this emphasis.

Winckelmann believed that climate and geographic location affected art (this idea was later developed by Taine). According to Winckelmann, the greatness of Greek art was a product of the light quality of its Mediterranean climate. The beauty of the Greek depiction of the human form was caused by the healthy lifestyle this climate allowed. He even stated that one must be in this climate to have the full experience of beauty: "and so the time and full knowledge of beauty in art can be achieved in no other way but by contemplation of the original paintings themselves, and especially in Rome."[5]

Winckelmann's contribution to art history is well known. He was the first historian to describe a cyclic history of art; art evolved, he said, from primitivism to sophistication to decline and oblivion. In actual Western art history this meant that the greatness of classical Greek art declined under Rome, revived at the time of the Renaissance, and declined again in the seventeenth and eighteenth centuries (with the exception of Mengs and Neoclassicism).

As an art theorist he was dogmatic and had a narrow interpretation of excellence in art. This narrow focus seems to be at odds with his own statements about beauty. For example, he said, "Beauty is one of the great mysteries of nature, whose influence we all see and feel: but a general, distinct idea of its essential must be classed amongst the truths yet undiscovered. If this idea were geometrically clear, men would not differ in their opinions upon the beautiful, and it would be easy to prove what true beauty is."[6]

He states that beauty is indiscoverable, at least distinctively, and yet he ignores this idea and offers in his writings on art an absolute standard. It must be pure, linear, and possess noble simplicity. He states that beauty is "like water"—there is only one absolute best, the one "free of all foreign admixture," the one that satisfies his criteria of simplicity and stillness.[7] He was above all else a believer in absolutism and in that sense, he was a curiously Romantic and irrational figure.

David Irwin points out an aspect of Winckelmann's writings on art, noting that his descriptions of art work, and particularly the ancient sculptures that played such a large part in his theory, belong more to the Romantic movement than to the age of reason.[8] His descriptions of the *Laocoön* and the *Apollo Belvedere* are examples of Impressionistic and imaginative writing. He sees anger in a nose, contempt in a lip (of Apollo) and a range and depth of feeling in the eyes of the figure of the Laocoön. Despite his conservative classical theory, he freely uses his imagination to express his creative urges. These interpretations often reveal an emotionalism that exceeds any rational or strictly classical disposition of the work.

It is also important to consider Winckelmann's influence not only in art history but also on Hegel. It was from Winckelmann that Hegel received many of his ideas on art, in particular the supremacy of sculpture over painting. It is also clear that Hegel's speculation that painting would evolve into philosophy was influenced by Winckelmann's ideas on its innate and inferior abstract qualities.

With regard to Winckelmann's contradiction, one must again emphasize that a totally rational approach to understanding the arts, the visual arts in particular, is almost impossible to accomplish. Mankind's natural reaction to art is emotional, not necessarily intellectual. Any attempt to codify beauty or excellence runs the risk of creating standards that have little correlation with many masterpieces of art.

11

Sir Joshua Reynolds

Sir Joshua Reynolds (1723–1792) was a painter who became the first president of the English Royal Academy in 1768. He was not as dogmatic as Winckelmann in his adherence to classical principles. He was committed to the classical ideal of beauty and particularly to the necessity of studying ancient sculpture and masterpieces of classical painting. He also adhered to the qualitative scale of subject matter in painting that placed historical painting at the top, with portrait, landscape, and genre subjects in descending order of importance. The loftiest beauty, according to Winckelmann, was characterized by an absence of individuality and an obedience to universal rules for painting; however, Reynolds believed that genius could transcend these rules; this reveals his transitional status as a late classical and early Romantic theorist.

Reynolds's writings on art are contained predominantly in his fifteen annual discourses or addresses to the academy at their award meetings. In these addresses he describes his classical theory, which includes a germ of Romanticism. He emphasizes the importance of the fancy and the imagination of the individual artist, in addition to the use of pure reason. He even extols the merits of seventeenth-century Dutch genre painters, telling young painters that they can learn from studying them, that their imitation is true and pleasurable. He adds that for a painter to create the highest beauty he must go to Italy to learn from the highest "branches of knowledge."[1]

His fourteenth discourse contains an evaluation of the work of Thomas Gainsborough, who had recently died. Gainsborough was not a classical painter of the grand style and did no history painting in his career. This was a fact that should have relegated him to obscurity

in the eyes of a traditional classicist, but Reynolds praises his coloris-
tic harmony, his unity, and the character of his subjects. Though he is
not placed at the highest level of painters, Reynolds states that he is at
least better than second-class grand-style artists such as Raphael
Mengs (championed by Winckelmann).[2]

A visual clue to the Romantic tendencies of Reynolds can be seen in
his painting *Omai* (1776). The subject of the painting was a Polynesian
brought back by Captain Cook in 1775. Reynolds painted the young
man as the personification of ideal beauty, the noble savage in *The
Pose of the Apollo Belvedere*. As Rosenblum has noted, this early use
of a classical pose to record a current event would become a character-
istic of nineteenth-century Romantic painting.[3]

Reynolds's concessions to artistic genius belies his strict classicism.
He was less dogmatic than Winckelmann because he allowed great art
to exist outside a narrow and arbitrary theory of classicism.

The history of Western thought on art and the aesthetic seems to de-
scribe an aesthetic theory in conflict with rational thought. Classicism
in all its variation was concerned with incorporating rational thought
with artistic production. Yet a totally satisfactory aesthetic theory
could not be developed because art has essentially more value for peo-
ple than mere instruction.

12

The Salon Shows

In the Renaissance, prominent artists would often display a work of art in a public place before it was taken away by its purchaser, but the idea of major artists currently working in a country having a group show originated with the French Academy salons. Joseph Sloane, in *French Painting between the Past and Present*, notes that 230 critics wrote salon critiques between the years 1840 and 1870.[1] Many of these critics supported academic principles. Some, like Zola and Baudelaire, were Romantics; some late Romantics or early Modernists, like Thore, admired Millet and were called Humanitarians because of their interest in social welfare. Others championed Objective Naturalism, like Champfleury and Duranty, who praised Courbet.

A show not intended for the general public was held at the Louvre in 1667. The first show open to all citizens took place in 1737. Under the directorship of Antoine Coypel, bi-annual shows were held from 1747 onward, with the exception of 1749, when the academy canceled the show after being upset by the first journalistic critique of it by Lafont de Saint Yenne.[2] By this time, the academy printed its own report for each show and the paper *Mercure* also gave "positive" critiques and descriptions of members' work. The academy was not prepared for having its artists criticized or for having an independent critic giving them suggestions on how to improve their paintings. Into this world of evolving public interaction in art came Denis Diderot.

13

Denis Diderot

The model for the modern independent art critic was established by Denis Diderot, who began writing critiques of the salon shows (1759–1781). Although he wrote for the public, not the artists or salon members, he published, in his lifetime, only the critique of the 1759 salon. He left the other critiques to be privately distributed among friends because he did not wish to take an active part in the warfare of contemporary amateurs, whom he generally despised.

Denis Diderot (1713–1784) was one of the major philosophers of the intellectual movement sometimes called the Age of Reason or the Enlightenment. He spent most of his life writing the French encyclopedia. He was in part a philosophical materialist, sharing many ideas with British empiricists. His ideas and beliefs on religion and the existence of God changed radically during his lifetime; at one time he was an atheist but later in his life he came to believe all nature was God. It was his concern for morality, along with his independence of thought, that was most characteristic of his salons.

Unlike Lafont de Saint Yenne, Diderot wrote to enlighten the public and not to correct the artist. Usually his focus was on the decadence of the art exhibited. He hated the Rococco style of painting, epitomized by the sensual nudes of Boucher. He believed this style to be at least trite or trivial and at worst, destructive of society. His heroes in painting were Chardin and Greuze. He praised Chardin for ennobling the French middle class, showing them as hardworking and responsible people. Jean-Baptiste Greuze (1725–1805) most closely epitomized Diderot's ideal artist, at least until the arrival of David late in Diderot's life. They shared a concern that painting concentrate on instructing moral behavior.

Diderot demanded accurate realism and argued that the best way to judge a work was to compare it with its original in nature. Diderot, like Reynolds, understood that a genius could create new rules for art. When discussing a painting in the salons, his approach was to treat it as a living person or actual location that he can interact with. Often these narratives end with the moral message of the work, but it would be incorrect to consider Diderot simply a moralist preaching to a congregation. Diderot's critiques are alive with his own complex interests and personality. There is a love of the sensual in life throughout his salons.

In his critique of Greuze's *Young Girl Crying over Her Dead Bird* in his salon of 1765, he talked to the girl and "discovered" by her actions (in the painting) that she is really crying over the loss of an unfaithful lover; the dead bird is a symbol and substitute for a loss of virginity.[1]

Even more important than his manner of writing is his aesthetic theory. Diderot offers an art theory that is a radical departure from previous and subsequent theorists. In particular, Diderot's flexible metaphysical position offers an art theory and critical approach that is both Materialist and Idealist, subjective and objective, and concerned with aesthetic experience and perception.

During the seventeenth century, Rationalism, epitomized by René Descartes, was coming into conflict with a new emphasis on empiricism led by the British. This emerging tendency to comprehend nature through an inductive method influenced the circle of French philosophers around Diderot, including Buffon, La Methie, and d'Holbach. Diderot's adoption of these new ideas was not complete; he was the product of both world views. He accepted the Baconian–Newtonian experimental method, but also kept a belief in Descartes's principle of matter in motion.[2] He was both a Materialist and an Idealist.

The emerging science of biology greatly influenced and directed Diderot's philosophy, in particular, his concept of a vitalistic nature. In medieval times, nature was considered of little importance for man or religion because it was understood that matter was separate from God. During the Renaissance, this view began to change.[3] Giordano Bruno, for example, speculated that God was not an "external intelligence" but that it was "more worthy for him" to be the internal principle of motion guiding all the entities of nature.[4] This emergence of the conception of divine nature impelled and guided Italian art theory from Alberti to Bellori. Another by-product of this synthesis was that a new importance was placed on the individuality and variety of the objects of nature—or matter itself.

Thus, in the Renaissance period two antitheses were implicitly established. There was both the impulse to create absolute and logically independent proofs of God's existence in nature, and an impulse to understand nature through an examination of the particular and empirically experienced. Diderot seems to exemplify a synthesis of these aspects: what one could characterize as his hyphenating thought.[5]

Diderot described nature as being in constant flux. This was not an arbitrary position, but rather an indication of his belief that no particular viewpoint can do justice to the inner variety and dynamism of nature. Since he understood nature to be fluid and fleeting, not totally materialist or idealist, his own approach mirrored this dynamic and restless model.[6]

Just as Diderot struggled to understand the qualities of nature, he also struggled to believe in a divine creator. He has been variously described as a deist, a skeptic, and an atheist.[7] Early in his career at the time of his writing *Pensées Philosophiques*, Diderot expressed the Deist argument that nature could not be explained by a blind mechanism. Current biological studies convinced him that the qualities of nature were purposeful and adaptive. But Diderot could not agree with Descartes and his followers that this purpose came from a supranatural intelligence. This point was made clear in his *Lettre sur le Aveugles*, and has led some to believe that he was an atheist. But one can equally argue that his atheism was highly qualified. In particular, Diderot endowed nature itself with the creative powers formerly reserved to God.[8] This interpretation served two important functions: it freed nature from the finalism of an extra or supernatural intelligence; perhaps more important, it deprived theology of any authority regarding current biological research.

Diderot's art theory is an outgrowth of his hyphenating thought and contains the same combination of materialism and idealism. It is also the logical development of his earlier interest in scientific observation, but it is different in that it expresses a type of perception that can most easily be called aesthetic. This aesthetic approach can be identified by the intensity of his personal involvement in his critiques, quotes about his experiences with visual art works, and his metaphysics and art theory considered on their own.

In Diderot's time there was a proliferation of theories on art and beauty.[9] Diderot agreed with materialists like Hume, Hutcheson, and Du Bos that beauty was determined by the potentiality a work of art had to produce pleasurable sensations in the spectator. The practice of following prescribed rules for art or copying ancient models could still be worthwhile, but only if it aided in reaching this objective.

Funt has pointed out, however, that Diderot's idealism prevented him from accepting the British empiricist separation of sensation and reason.[10] Their conception that one's ability to appreciate beauty was determined by an innate faculty of taste that existed outside reason was unacceptable to Diderot. Perception (including aesthetic perception) was for Diderot a process of thought and not the immediate apprehension of simple sensations. He considered it to be a complex process that involved the transformation of preconscious concepts or first thoughts into conscious experience. One comprehended and appreciated beauty by experiencing these first thoughts or intuitions, and they differed from mere sensations because they were immediate and yet thoroughly prepared.[11]

In spite of Diderot's differences with British materialism, he has been acknowledged as a precursor of nineteenth-century materialism and Positivist art theory.[12] Diderot's art theory, although empirically oriented, does not conform to the Positivist's position. It is clearly not based on the conception of a scientific model emphasizing objective observation and the accumulation of data. Diderot would have found this approach simplistic and erroneous in explaining the perception of the beautiful. Diderot would have concurred with Steven Pepper in believing that refined empirical data covered only a very small field of knowledge. Alternative norms of evidence are required to understand nature or beauty, in all its complexity.

An artist, according to Diderot, produced a beautiful work of art through a combination of factors: close observation, hard work, use of the imagination, and the ability to rediscover one's first thoughts. An implicit or intuitive reasoning guided both the artist and the spectator with regard to the creative process and the appreciation of art. It was necessary for the artist as well as those who wished to experience their work to tap into an objective natural energy and vitality that is internal to nature. The ultimate objective of artists was to express the transcendent vitality of nature.[13]

As noted earlier, another important difference between Diderot's art theory and the Positivist's position concerns the concept of determinism. Positivism, particularly naturalism, emphasized a strong determinism with regard to the creation of art: artworks were predetermined by environmental and hereditary factors. Diderot accepted this strong determinism with regard to plants and animals but had reservations about it for man. Mankind's possession of a memory allowed for a measure of freedom of choice. This freedom was limited by the choices provided by environmental and hereditary factors, but

it again points out Diderot's unique position. Although he was an advocate for environmental and hereditary factors, he could not describe mankind's actions dogmatically.

Although Diderot believed that human beings possessed individual freedom, this should not be confused with an endorsement of a subjective reality. In accordance with his hyphenating thought, he believed that beauty was both universal and particular, both evolutionary and objectively based. The artist of genius did not copy from ancient models but dictated a new beauty in part derived from "the climate, government, laws, and circumstances in which he was born."[14] Like the materialists, he believed that empirically aesthetic experience and aesthetic judgments were largely subjective. But Diderot's admission of a subjective empirical world should not be confused with what he believed to be a normative aesthetic that was empowered by the transcendent features of nature itself. Beauty and the aesthetic were also derived from an objective and transcendent nature, and it was this life force that animated all matter.

Diderot's art theory has long suffered from both a misunderstanding and oversimplification. In particular, as we have noted, the philosophy of Immanuel Kant has separated us from Diderot's world. Kant's purpose in writing the *Critique of Pure Reason* was largely to refute David Hume's skepticism, in particular Hume's conclusion that analytic propositions were tautological and that mankind could know nothing with certainty. To answer this argument, Kant created not only the concept of a synthetic prior truth, but a system of innate prior faculties that determined, organized, and shaped our perceptions and thoughts. Space and time were designated the a priori synthetic formulations of perception, and the categories of the understanding, unity, plurality, totality, causality, and substantiality were the foundations that governed higher cognitive thought.[15]

With this system in place, knowledge was preserved from Hume's skepticism, but something was lost in the process. Traditional metaphysics was made superfluous, since the numinal world that existed outside one's perceptions was considered unknowable.

This almost total acceptance of Kant's metaphysical position has not only had the result of locking mankind into a world of subjective idealism, but has made it difficult for one to understand and appreciate philosophers like Diderot whose metaphysical speculations were an integral component of their philosophy.

Art criticism locked into a Kantian Zeitgeist produced two antitheses of equal extremes: Positivism, which we have considered,

and subjectivism. With metaphysics rebuked, the next logical step was to believe as the Positivists did, that empirical observation and the scientific method were now validated and supreme. Positivism became a popular viewpoint in art history despite the fact that Kant's system acknowledged the impossibility of objectively observing matter that was ultimately unknowable.

Excluding Positivism, the direction that art theory has gone since Kant has been one of a greater emphasis on subjectivity and interpretation, away from the concept of a transcendent aesthetic experience. An emphasis on meaning and interpretation divorced from a significant interest in the aesthetic has become the normative approach of most Postmodern art critics. Under the influence of Post-structuralism in particular, there is only an interest in interpreting works of art as symbols akin to language, that carry meaning or reference. This acceptance of a symbolic approach ignores both the debate over whether art is a symbol at all, and the tradition in art criticism of an interest in aesthetic experience and evaluating works of art based on qualities rather than references to things or specific ideas. Monroe Beardsley has noted that many examples of art—for instance, nonrepresentational paintings—do not appear to refer to anything, and that the characteristic way art is perceived aesthetically inhibits its ability to refer cognitively to particular concepts.[16] But this acceptance of the symbolic need not be dogmatic if it is allowed to function in ways that adequately describe both aesthetic experience and the creative process. Supporters of the concept of an autonomous aesthetic experience would have little objection if incorporated in the art symbol was an allowance for unconventionally determined meanings as well as the necessity of immediate apprehension. But the direction of symbol theory in the twentieth century has been away from the transcendent art symbol proposed by Susan Langer to extremely simplified and conventionalized forms of expression.

The definition of aesthetic experience given by Beardsley bears a striking similarity to the experience Diderot described in his salons. Specifically, Beardsley's requirement that the experience contain four or five qualities or symptoms (object directness (necessary), felt freedom, detached affect, active discovery, and a sense of wholeness) seems to be echoed in statements by Diderot.[17] A quote taken from a critique of a painting by Robert seems to suggest all Beardley's qualities. Diderot states: "One forgets oneself in front of this work; it is art at its most magical, one is not longer at the salon or in an artist's studio, but in a church, under a vault; a touching serenity and solace, a delicious freshness prevails there."[18]

In a critique of Vernet, he again expresses the uniqueness of aesthetic experience. He states: "Where am I at this moment? What is all this surrounding me? I don't know, I can't say. What's lacking? Nothing. What do I want? Nothing. If there's a God, his being must be like this, taking pleasure in himself."[19]

For Diderot, the primary purpose of the artist was to aestheticize one's experiences, not merely to convey ideas. He uses the phrase, "the magic of the brush," to convey this emphasis. In comparing the qualities of two paintings by Robert, he states:

> The first is a work of the imagination, while this one's an imitation of art; here one is interested only in the idea of the vanished power of the people who built such edifices: one doesn't reflect on the magic of the brush, but on the ravages of time.[20]

Diderot was clearly making an evaluative distinction. The canvases by Robert conveyed similar meanings—ideas about a vanished past—but the superior one also produced a correspondingly stronger aesthetic affect, or experience.

It is also clear in Diderot's writings that he understood that the perception of art differs from one's ordinary perceptions. Diderot did not consider all the arts equally adept at producing this experience; he gives the visual arts a unique aesthetic position. He states:

> The painter who can express but a moment of time has not been able to represent so many symptoms of dissolution as the poet but they are much more affecting; the painter shows us reality, whereas the expressions of the poet and musician are but symbols.[21]

The immediacy of the painters' craft and their ability to exemplify the world of nature place the visual artists in a special position for Diderot. They are not merely manipulators of symbols but deal directly with the vitalism of nature itself. The vitalism of nature realized by the visual senses characterized Diderot's lifelong interest in visual perception as well as the visual arts.

Diderot's writings also hint that his fascination for "the magic of the brush" was in conflict with his cognition. One can imagine a battle raging between Diderot's materialist leanings and his idealist and vitalist beliefs.

In his acclamation of the work of Chardin, he seems to challenge philosophy, specifically, cognitive disputation in explaining aesthetic experience. He states:

> If it's true, as the philosophers claim, that nothing is real save our sensations, that the emptiness of space and solidity of bodies have virtually nothing to do with our experiences, let these philosophers explain to me what difference there is, from four feet away from your paintings, between the creator and yourself.[22]

Despite the current popularity of semilogical analysis in art criticism, one should remain aware of the questionable premise underlying the idea of art functioning as a symbol and divorced from aesthetic considerations. Art theory, practice, and criticism without an emphasis on a transcendent aesthetic experience seems to lose much of what has made art most valuable for mankind. Diderot's writings on art and his art criticism bring back not only a time (the Enlightenment) when experience was more open to a variety of interpretations but a time when the sources of art and art criticism were associated with the transcendent and the universal as well as the specific and subjective. Diderot's requirement that the visual arts transport us to an aesthetic experience is largely absent in today's art critical theory. His writings on art as well as that of others who express an autonomous aesthetic experience can bring back an awareness of the importance of such experience to the art world. His hyphenating thought, in contrast to the legacy of Kant, brings back not only an interest in metaphysics as a worthwhile branch of philosophy, but an interest in the possibility of transcendence in art itself.

The demise of the academy and the classical ideals that it legislated was begun by individuals who supported many of its tenets, for example, De Piles, Du Bos, and Diderot. Romanticism in the guise of a more emotional and inventive form of classicism could not deal academy classicism a death blow. Its differences lay mostly in its emotional content, lack of traditional decorum, and general lack of clarity in its narrative. The real threat to academy classicism came during the nineteenth century with a variety of new threats that tended to emphasize the subjective and sensual over the universal and morally instructive.

A new school of realism in painting was an important break with classical devices, as was a concern for formalism and pictorial values, instead of the traditional emphasis on the subject and its moral message.

The idea of "art for art's sake" popularized by the critic Theophile Gautier emphasized the need for artists to be free to follow their own instincts for beauty without having their work serve moral functions—as was the case with classical history painting. Another important factor was the broadening of the art public and its growing lack of religious and mythological education. The art public included most classes and they were, in general, unable to decipher the meaning in allegorical painting. They were neither familiar with the stories from antiquity nor were they aware of the meaning of the objects or events depicted in biblical stories. To counteract this problem, the academy began to print explanations of the stories of their paintings in their official catalogue in the 1850s, but this growing lack of understanding undermined the ideals of classical history painting.

14

The Romantic Critics

The critics of the Romantic movement, in particular Baudelaire, helped undermine academy classicism and created the factors necessary to establish the modern movement. This was a time of public interest in the visual arts and it became more common for many newspapers to print at least short reviews of the salons. French art journals, such as *L'Artiste* and *Le Gazette des Beaux-Art*, were also established to meet the needs of an ever increasing art public.

Increasingly, art was being regarded as the personal expression of the artist and the expressive theory of creation was replacing the idea that art was the imitation of ideal nature.

The idea that art was about personal expression was combined with a yearning for the infinite. At the center was an increased regard for human imagination and the belief that it could lead to an autonomous realm of transcendental value. This Romantic notion of sharing a new consciousness similar to the divine was often combined with a new sense of artistic freedom and interest in the pleasure characteristic of aesthetic appreciation. The Romantic movement was often synonymous with aesthetic concerns. Art theorists like John Ruskin, Charles Baudelaire, or Walter Pater took ideas about the creative imagination and applied them to painting. They may have disagreed with the instrumental value of art but they advocated the concept of an autonomous aesthetic experience that was intuitive and different from our regular cognitive functioning. In all of Romantic theory there was implied a spiritual quality that cannot be considered rational. Many aesthetic concepts, including the role of the imagination and pleasure in art, were explored in this climate of irrationality.

15

Charles Baudelaire

Charles-Pierre Baudelaire (1821–1867) was one of the most important French poets of the nineteenth century, in addition to being an original and gifted art theorist and critic. His emphasis, as a poet, on the evil aspects of human behavior was seen as destructive to public decency. As a result, his book *The Flowers of Evil* was withdrawn from publication by the state and six of his poems were banned as offenses to public morals.

The tendency in Post-modern times is to view Baudelaire, as well as his fellow Romantic John Ruskin, as being perverse, inconsistent, or contradictory in their thinking. Their statements about art are claimed to be unreliable because they are either being insincere or nihilist, in the case of Baudelaire, or irrational, in the case of Ruskin. But these views are not representative of the Romantic sensibility, which, although it emphasizes personal feelings, also suggests a transcendent source of those feelings.

Baudelaire was not a nihilist; his salons and essays on art offer a wealth of new and revolutionary ideas that are productive rather than destructive. He saw, while observing the decadence and decay of the classicism of his time, the need for a new art. The problem was that, except for a few notable examples such as Wagner in music, Poe in literature, and Delacroix and Guys in the visual arts, this new art had not yet arrived.

Romanticism can be thought of as a state of mind—an emotional attitude toward life and art. It became an organized movement during the nineteenth century, when its ideals were expressed most clearly and forcibly by Baudelaire in his essay "Further Notes on Edgar Poe." In this essay he described the new modern artist. Artists, he believed,

are by their nature alienated from society because they are destined to pursue perfection or beauty in a world that is imperfect. They are hypersensitive individuals cursed with their genius. He calls them "genius irritable" because, in pursuing beauty, they overreact to the injustices of the world. To be true to the artistic vision, the artist must consciously separate from society and become an impassive or stoic and distant observer of society.[1]

The artist is also to be understood as an emotional and intuitive person and not a scientist or cognition-based thinker. Baudelaire praises, in his critique of Richard Wagner, the excesses of emotion that are conveyed by his music. In "The Painter of Modern Life," he further describes the modern artist as a dandy. He is a worldly and spiritual aristocrat who despises triviality, is never vulgar but observes the human behavior around him stoically; as for the courtier of Vasari or the street-smart artist of Clement Greenberg, it is necessary for artists to separate from the inferior culture about them.

Baudelaire believed that the art of his day lacked vitality and imagination while it concentrated on moralizing and technique. He believed that art ennobles man, that it has a moral effect, but he was against any art that intended to preach or instruct mankind. He states, "If the poet has pursued a moral aim, he will have diminished his poetic power; nor will it be incautious to bet that his work is bad."[2]

Like Gautier, he believed in the concept of "art for art's sake," and that utility was destructive to beauty. He was particularly eloquent in his dismissal of the concept of materialism and ideas of material and technological progress. The painter Courbet and the writer Hugo were ridiculed by Baudelaire because, as materialists, they believed in suppressing their own personalities and imaginations in favor of objectivity and scientific attention to nature. Baudelaire believed this to be the wrong approach for an artist and that the art that resulted from this approach would be superficial.

He was harsh on technological progress, including the new medium of photography. This type of artistic endeavor symbolized what was wrong with scientific progress in the arts. It was mechanical, uncreative, and dealt with the mere reproduction of the trivial.[3] To him, progress was a spiritual concept and was epitomized by an increase in imaginative powers.

Baudelaire believed that the problem with the traditional art of the academy and the objective naturalism of Courbet was that they failed to concentrate on individual emotion and imagination. Classicism was not vital or modern because it idealized the past and failed to express

the world of the present. Art must be free of the chains of utility and the empiricism of science to become vital, varied, and novel.

Beauty was not the product of rules but the product of imagination. It also contained what Baudelaire called "an element of strangeness."[4] The artists that he singled out for praise had this quality and a devotion to their imaginative abilities. For example, Delacroix was praised because he painted sickly women who also possessed an inner glow of beauty.[5] This element of the strange would result in the transformation of subjects that traditionally would be ugly or base into powerfully beautiful and emotional images.

It follows that with his belief in the alienated artist, who is both irritable and hypersensitive, he often associates great art with melancholy. It is the ability of the reader (or viewer) to feel melancholy after reading a poem or viewing a painting that can determine the work's excellence. This is because when we perceive these great works we enter into an "immediate possession of perfection or paradise." This would not by itself cause us misery, but the contrast of this ideal beauty with our own imperfect and material self results in our impatience and melancholy.[6] It is therefore the possession of a transcendent ideal contrasted with our everyday life that qualifies the experience of great art.

Beauty, for Baudelaire, was a concept that was both eternal and transitory. Gone is the idea of a universal and simple beauty that was a tenet of classicism; in its place is a combination of objective and subjective aspects. A painting, to be beautiful, must modernize a universal theme, make it vital, and then distill the eternal from the transitory. Many great paintings of the past, according to Baudelaire, have done this, for example, in works that dress people of a former time in contemporary clothing. Baudelaire believed that this subjugation of historical truth and the addition of the transitory aspects of contemporary clothing, manners, or practices actually enhanced and perfected its universal aspects; as he noted, if they had tried to dress them differently a falseness would have been created, and they would have looked like people at a costume party.[7] Part of being a modern artist was understanding that there was a transitory part of beauty that resides in the present. But equally important was the concept that beauty dealt with the universal and transcendent.

A comparison can be made of Baudelaire's ideas concerning the imagination and the ideas of the French Romantic philosopher Henri Bergson. This comparison is made not necessarily to show the influence of Baudelaire on later Romantic philosophy but to emphasize the

similarity in the Romantic sensibility toward materialism. Both men were, in part, reacting against scientific Positivism in philosophy and practice.

Positivism as a philosophical movement held that metaphysical speculation and theorizing about knowledge itself was unnecessary. Mankind, according to Auguste Comte (who developed the first form of Positivism in the early nineteenth century), had evolved to a point where metaphysics was not needed. Mathematical systems and the scientific investigation of matter and experience were of primary importance and only assertions that could be confirmed or rejected by empirical evidence were meaningful.

This way of understanding existence gave no importance to the concept of intuition or any personal knowledge that could not be confirmed by others. Romantic theorists, like Baudelaire and later Bergson, found it necessary to defend the concept of intuition and its importance in thought and knowledge. For Bergson, the mind has two aspects: intelligence and intuition. Intelligence, if used alone, is a negative term, since it refers to the habit or process of the mind in adapting symbols and categories to already known aspects of our environment. This process alone fails to capture the vitality and constantly changing aspects of life and the uniqueness of the individual members of any classification. For example, one can classify all pine trees as similar but if one looks at each one carefully there are more differences than similarities between them. The category of "pine tree" only captures some of the essence of its species. Intuition, if used with intelligence, helps one understand this essence more completely and leads to better and more correct categorizations. Bergson thought that intuition was the direct understanding of things and events with our unconscious instincts. He emphasized that even scientists are not positivists in their approach to their specialty since they need to utilize intuition in order to overcome habitual and stereotypical thinking in order to make breakthroughs and new discoveries. It was necessary at these times for scientists to dispense with outmoded thinking and to think intuitively, using their hunches and proving their ideas at a later time.

Baudelaire, in his writings on art, suggested a similar concern over a positivism in the arts. He believed that art and the aesthetic experience could not be understood in materialist terms. Art was transitory and materialistic but it was also eternal and ideal and existed regardless of the material world. He proposed that an intuitive use of the imagination was the best method to create and perceive this transcendent as-

pect of beauty. He stated, "Imagination is a virtually divine faculty that apprehends immediately, by means lying outside philosophical methods, by intimate and secret relations of things, the correspondences and analogies."[8]

The eternal reality of life is revealed to us when we use our intuition. We should look beyond the material images in a painting and "correspond" with the infinite. Bergson and Baudelaire both understood using intuition as a way of thinking that was justifiable and necessary.[9]

Baudelaire also emphasized the uniqueness of each artistic genius. He believed that artistic genius owed nothing to a teacher or method of study. He stated, "He (the artist) died without offspring. He has been his own kind, priest and God."[10] A genius was characterized as a man who could use a child's consciousness and yet also have the experience and maturity to express that consciousness and purity to others.[11]

Baudelaire's contribution to the development of modernism, art theory, and art criticism is extensive. He was the first of the Romantic theorists to describe the tenets of Romanticism, the emphasis on imagination and emotion over the objectification of nature and the production of art by following predetermined rules. His writings clearly express the Romantic shift from the imitation of ideal nature to a concern for the communication of individual emotion. He was also the first to describe in detail the qualities and intentions of the avant-garde artist that were to characterize the modernist movement, in particular the dissatisfaction with bourgeois society and the independence from imitation of previous styles and periods. He was a defender of "art for art's sake" and set the stage for High-modernism's separation from moral instruction in the arts.

Like De Piles before him, he emphasized the need for the theorist to look for various types of beauty and to be concerned with the formal as well as literal qualities of the work. A good critique was to be entertaining and poetic as opposed to logical or moral. Great art was to be perceived by the critic intuitively or aesthetically with sensitivity and taste.

One final point regarding Baudelaire's influence on later modernist art theory was his contribution to the severing of moral instruction from art. The notion of "art for art's sake" can mean many things besides the autonomy of beauty and its separation from usefulness. It can mean that art should still be concerned with morality but only as an outgrowth of a concern for beauty. By contrast, it could mean the more severe interpretation of "art for art's sake" later defined by the High-modernist movement, in which moral content came to be

considered merely political and was therefore an obstacle to creating and perceiving great art. Unlike Post-modern theory, Baudelaire's aesthetic theory was objective as well as subjective. Ultimately, he believed that the contrast of an ideal spiritual reality with an inferior empirical one made one conscious of the power of great art.

16

"Art for Art's Sake"

Post-modernist art theory has an ambiguous relationship with the phrase "art for art's sake." It has negated modernism's emphasis on the importance of beauty and the dangers of instruction in art while also adopting aspects of a late modernist interpretation of the phrase. This point is the source for the misunderstanding of the original meaning of the concept.

The phrase "art for art's sake," first popularized by Theophile Gautier and developed by Charles Baudelaire, emphasizes the need for artists to be free to follow their own instincts for beauty without having their work serve moral functions, as was the case with classical history painting. The concept of art for religious instruction, long a prominent goal and tenet of classicism, was greatly altered by this concept but not totally abolished. As discussed, Gautier's and Baudelaire's interpretations of the concept reflect the fact that these critics lived at a time when the meaning contained in classical history painting was becoming lost to the majority of the art public. The audience for painting was broadening and becoming increasingly uneducated in religious and mythological instruction. They were, in general, unable to decipher the meaning in allegorical painting. Baudelaire believed these paintings were anachronisms. The art world needed a new modern art that would rely more heavily on the imagination of the artist than on an adherence to past principles. He was against art that intended to preach or instruct but believed that art ennobles us and has a moral effect.[1] Baudelaire's prescription for this new art was to direct artists to create for the sake of beauty and abandon a utility (moralizing) that would be destructive to this beauty. It is important to note that this idea cannot be simplified to mean that art should be unconcerned with

morality. Art was still to be "moral" but only as an outgrowth of a concern for beauty. Baudelaire was an idealist who was concerned with the effects of materialism and technology on the field of art. To him, progress in art was a spiritual concept and was epitomized by an increase in imaginative powers. He warns that artists (like Hugo) who neglect this faculty and emphasize an objective and scientific attending to nature will produce work that not only lacks beauty but is superficial or trivial.[2]

The concept "art for art's sake" began to be interpreted more narrowly during modernism and High-modernism to mean that any political or moral content of any kind needed to be removed from art. But this apoliticism of art emphasized by High-modern critics such as Clement Greenberg and Theodore Adorno was motivated by a Nazi presence that was threatening to engulf the world of the late 1930s. The concept of a dogmatically narrow definition for "art for art's sake" was problematic from the beginning. Most art contains political content and can be interpreted in a variety of political ways. The important concept with regard to "art for art's sake" is that it was used by Baudelaire to emphasize that artworks existed for more than the political or any moral agenda. This same emphasis needs to be reintroduced into current art education.

17

John Ruskin

John Ruskin (1819–1900) was the most influential English art theorist of the nineteenth century. Ruskin believed in the supremacy of nature in art and his ideas and theory did not translate so easily to modernism. In his writings, particularly *Modern Painters* and *The Stones of Venice*, he helped form the aesthetic taste of Victorian England. Later in life he wrote exclusively of his ideas on social reform and abandoned his emphasis on art.

Although his writings are extensive, his aesthetic theory and criteria for critical judgments are contained primarily in the first two volumes of *Modern Painters*, where he attacked academic art, conventions, formulas, and the admiration and copying of Raphael. Ruskin emphasized the need for artists to be truthful to nature and to use their imaginations. He defended the artist Turner, and believed that he was more truthful to nature than the academy landscape painter Claude Lorraine. He believed artists needed to educate their visual senses by direct exposure to nature in order to understand true or divine nature.

Ruskin believed that the visual experience of nature and art was distinct from other cognitive experiences. If one had the sensitivity acquired through a careful examination of the natural world, one could create and appreciate divine beauty. At this stage of sensitivity "divine love" was directly involved with our perception of the physical world. Ruskin's criteria for art and art criticism were entrenched in an unqualified devotion to nature. Unlike Baudelaire, who had no faith in a divine or benevolent natural world, Ruskin believed in a divinely good natural world.

Ruskin proposed and preached an education of the senses throughout his writings. He believed that the true appreciation of natural beauty was more than a sensuous gratification, but rather "theoria," a

contemplation or aesthetic union with God.[1] Mankind's primary function in life was to be a witness to the glory of God; he thought this was best accomplished through the visual experience of nature and indirectly through art, which was to Ruskin an inferior and yet valuable form or aspect of God's creation.

He categorically linked art with religion and morality. His puritanical upbringing led him to distrust the value of sensual aesthetic experience, so the notion of "art for art's sake" was diametrically opposed to his ideas on art and its purposes. The glory of God, nature, and art were linked in a mystical perception of nature that was poetic and conveyed his faith that a detailed study and description of nature would reveal the consciousness of God.

Ruskin believed that the art of his day had lost its spirituality. The emotional and spiritual link with nature had largely been lost from Western art since Raphael. He believed that art after the great Renaissance artists was "infected with the sleep of infidelity."[2] The solution was for artists to return to nature and stop relying on the conventions of the academies.

John Ruskin was indifferent to many of the painters of his time who would become the forerunners of modernism. He preferred Turner and later, the Pre-Raphaelites. He idealized the medieval and Gothic periods and admired the fourteenth- and fifteenth-century Italian primitives, such as Giotto and Fra Angelico. He also admired the Venetian school, Tintoretto in particular. He believed that these times or these artists possessed a spiritual link to nature.

Ruskin's conception of the Gothic period was far from accurate. He had a romantic yearning to create a period that would be his ideal, in which artists and craftsmen suppressed material concerns and took delight in glorifying God. The late Middle Ages might certainly be described as a time of religious and spiritual involvement; however, it was also a time of fear and superstition in which artists worked for protection and profit as well as spiritual edification and faith.

Ruskin's later writings on art, such as "The Seven Lamps of Architecture," moved from a concern for aesthetic considerations and changed to an interest in the social conditions necessary for art and artists. He stated, "I believe the right question to ask respecting all ornament, is simply this; was it done with enjoyment, was the sculptor happy while he was about it."[3]

Ruskin believed that great art was dependent on a moral society. He linked greatness in painting with the morality of the artist (as Vasari had done). This was an erroneous idea, as research in art history would reveal. Even if it is possible to ascertain the moral state of the artists of

the past, this has little to do with how their work has been valued and assessed aesthetically. Fra Angelico, an artist that Ruskin championed, may very well have been a pious and deeply religious man. Tintoretto, on the other hand, was probably not moral and pious if existing letters and correspondence reveal his true traits and interests. Ruskin's interest in improving society was a natural outgrowth of his religious faith, but it had the result of further distancing him from the world of art and art criticism.

The major conceptual problem with Ruskin's theory was his insistence on the importance of the visual truth of nature and his seemingly contradictory notion that art was the product of the imagination. This contradiction caused irreparable damage to the intellectual fabric of his work as an art theorist.[4] For example, in volume 1 of "Modern Painters," he defends Turner as more truthful to nature than the academics but not as an artist of imaginative force. Certainly the two concepts are at odds since the imagination, if used to any extent would threaten to destroy any truthfulness to nature, and maintaining the primacy of truthfulness would seem to destroy the notion of the artist's freedom to interpret nature. Ruskin's definition of the imagination is unclear and limited in his theory except when it comes to his hatred of academic copying. He wanted artists to follow their hearts and not conventions or rules.

To understand Ruskin one must realize that he was a Romantic theorist who often emphasized a mystical interpretation of reality. One must be careful not to judge him on his logical arguments alone but on the persuasiveness and emotionality of his prose. For Ruskin, the aesthetic experiences of art and nature were both mystical and divinely rewarding.

It is also clear that Ruskin's visual experience of nature and art was an aesthetic one. It was characterized by intense involvement, intuitive feelings of pleasure and wholeness and a distinctness from our everyday cognitive experiences. The aesthetic response to nature and art characterized Ruskin's writings from the beginning and colored his prose throughout his career.

There is a mystical and highly emotionally charged quality in Ruskin's writings that defies explanation and requires one to read him. His poetic power can be seen in a passage from *The Poetry of Architecture* concerning his ideas on the natural placement of cottages:

> It is for this reason that the cottage is one of the embellishments of natural scenery which deserves attentive consideration. It is beautiful always, and everywhere. Whether looking out of the woody dingle with its eye-like window,

and sending up the notion of Azure smoke between the sil-
ver trunks of aged trees; or grouped among the bright corn-
fields of the fruitful plain; or forming grey clusters along the
slope of the mountainside, the cottage always gives the idea
of a thing to be beloved: a quiet life-giving voice, that is as
peaceful as silence itself.[5]

Another problem with Ruskin besides his logical inconsistencies
was his inability to reconcile his love of the sensual and visual with his
own religious beliefs. One example of this problem was his refusal to
even use the term aesthetic because he felt it was a sensual term and be-
neath the experience one should have with great art. It was in large
part his religious beliefs that caused his confusion over imitation and
the imagination. Since natural phenomena were created by God,
Ruskin believed it was necessary for artists to follow visual nature ex-
actly, but he also exemplified a personal and highly expressive inter-
pretation of nature and abhorred copying.

John Ruskin was the most popular art critic of his time because his
imaginative and poetic style of writing and his concern for morality in
art fit the sensibilities of the people of the English Victorian period,
who were not willing to divorce art from its instructive and moral
functions.

John Ruskin's ideas on art, in particular the need to sensitize oneself
to visual phenomena, influenced a younger generation of art theorists
including Walter Pater, Oscar Wilde, Arthur Symons, and Roger Fry.
These theorists emphasized the importance of aesthetic experience but
largely ignored Ruskin's religiosity.

18

Walter Pater

Walter Pater (1839–1894) was an aesthetic, in the sense that his ideas on art centered on the need to have an aesthetic experience without regard to any practical or moral purposes. While appearing to be a conservative in his views on religion and morality, Pater was really a free thinker who greatly influenced the direction that the British aesthetic movement took, and was a great influence on the Epicurean and liberal views of his student Oscar Wilde. Unlike Ruskin, Pater had doubts about the existence of God and suggested this skepticism in his writings. In his conclusion to his major work, *The Renaissance*, he stated, "We are all under sentence of death but with a sort of indefinite reprieve, that is in art and song."[1] The value that aesthetic experience offers mankind becomes qualified. It is a value that is more subjective, abstract, and personal than Ruskin's revelation of an absolute reality. A new modern spirit is identified in which nothing can be known, except relatively and under conditions. With Pater, in particular, there is a growing tension between recognition of a subjective existence and a desire for the universal. But Pater makes it clear that the art theorist should concentrate on the particular rather than the universal in practicing his vocation. He stated, "To define beauty, not in the most abstract, but in the most concrete terms possible, to find, not a universal formula for it, but the formula which expresses most adequately this or that special manifestation of it, is the aim of the true student of aesthetics."[2] Metaphysical questions, according to Pater, were of no interest to the aesthetic critic.

But it is also clear that Pater believed that art and nature could offer a transcendent value. Since the aesthetic experience of art could offer the illusion of the infinite, if not the actual thing, it was valuable and

could enrich our lives. This more skeptical assessment of the value of art was shared by many with the same world view, for example, the Romantic and pre-existential philosophers, Friedrich Nietzsche and Arthur Schopenhauer. There is in Pater an existential angst, and his actions in life (he regularly attended church) reflect both a desire to believe in absolute reality and a logical skepticism that mitigated its possibility. This tension between the universal and particular, the absolute and the relative also colored Symons, Wilde, and Fry, and is largely absent from Post-modern art theory. Although Pater was not concerned with the universal in art criticism he was concerned with the transcendent in his art theory. Art offered a transcendent value by offering an illusion of the infinite, if not the infinite itself.

19

Modernist Art Criticism

Modernism was to a large extent a product of the Romantic movement; they shared many of the same ideas, for example, the emphasis on originality and the free use of the imagination. In addition, the concept of the Romantic avant-garde artist, separate and aloof from society, was also a characteristic of the modernist artist.

Modernism as an artistic movement had its beginnings in France after the revolution. In general, it was an evolutionary movement toward abstraction and away from mimesis. In particular, the notion of a moral or instructive use for painting was largely ignored. The major artists of modernism in the nineteenth and twentieth centuries tended to avoid this moralizing in the majority of their work and follow a path of increased formal and abstract experimentation.

20

Roger Fry

Roger Fry (1866–1934) thought of himself as a painter, a critic, and an art historian, in that order. He reacted to the moralizing of John Ruskin and the aesthetic bliss of Pater by creating his own scientific and formalistic theory of art and art criticism. He developed his formalistic aesthetic theory from his study of primitive art and the art of the Post-impressionists, particularly Cézanne. The idea of acknowledging the design of a painting, its "decorative effects," divorced from its subjective or literal interpretation, had been a part of art criticism from the Renaissance, but it had largely been considered unimportant. We have noted that among art theorists prior to the nineteenth century, Roger De Piles placed the most importance on this aspect of an artwork. Beginning in the nineteenth century, formalism, or the notion that the art critic should emphasize the abstract properties of the artwork, its balance, color, form, directional flow of composition, pattern, and center of interest, became increasingly important in relation to the effect that its subject matter had on the viewer. The culmination of this development can be seen in the ideas and writings of Fry.

Roger Fry was not a Romantic art critic; his taste in art and the scientific and dispassionate tone of his writing bear witness to a change in sensibility from a Romantic skepticism toward science to a new optimism about what it offered to humanity. In his devotion to science and progress, Fry has a definite modernist sensibility.

Roger Fry was an early supporter of Cézanne, whose methods of abstracting visual form forecast much of twentieth-century modernism. His approach, emphasizing a scientific analysis of the formal qualities of an artwork, became the dominant approach used by art critics in the twentieth century.

Roger Fry had a low opinion of John Ruskin's ideas on art, but he shared with him the Romantic desire to establish a meaning for art and aesthetic experience that was greater than self-indulgence or pleasure. He accomplished this by creating his own mystical interpretation of aesthetic experience.

Fry believed that there was a world of reality and a world of "pure form." One has access to the world of pure form only through one's aesthetic sense. This sense can be easily distracted by nonartistic associations, such as the literary, social, or political content of a painting. He believed that artists must remove these distractions and concentrate on the pure form. He renamed this concept "significant form," using a term that had first been introduced by critic and friend Clive Bell.

Fry's emphasis on the structural analysis of the artwork was also in part influenced by the work of Immanuel Kant. As stated earlier, at the beginning of the nineteenth century, Kant had revolutionized philosophy by proposing that the mind was an active organ that determined, to a great extent, the nature of the world one perceived. A correspondence with matter was impossible and one's perception of the world of matter was subjective and coherence based.

In Germany, art critics Conrad Fiedler and Adolf Von Hildebrand were influenced by Kant's distinctions regarding knowledge of the material world and they developed the idea that art theorists should make a distinction between reality and the pseudo objects that artists really create. Since artists interpret nature rather than reproduce it, it also follows that art must follow with its own structure and rules.

Although, as Falkenheim has pointed out, it is impossible to prove any direct influence of Fiedler or Hildebrand on Fry, one notes a similarity in Fry's idea of the role of the artist in using the intellect to create order and structure out of the chaos of our perceptions of nature. She also stated in *Roger Fry and the Beginning of Formalist Art Criticism* that other English critics such as Ram Stevenson and Lawrence Binyon were also writing formalist art criticism.[1]

What is a formalist approach to art criticism? It is a critical style that emphasizes the abstract qualities of form and formal organization in evaluating artworks. It often neglects or denies external aspects of the artwork including subject matter, the purpose of the artist, and intentions for the work.

Roger Fry's formalism is often qualified with some reference to the subject and the artist's intentions. For example, in his critique of Daumier's *Gare St. Lazare,* he states:

[T]he first impression derived from this is of the imposing effect of the square supports of the arcade, the striking and complicated silhouette of the man to the right, the salience of the center figure so firmly planted on his feet, and the contrast of all this with the gloomy space which retires to the left, and finally the suggestion of wide aerial spaces given by the houses glimpsed to the right. . . . In between these we see the two poor people waiting patiently and uncomplainingly against the column, and share for an instant Daumier's slightly sentimental attitude about the poor which helps to excite, by its adroit contrast, our critical feelings towards the professional gentleman, and we come back to note the avaricious grasp with which he clutches his umbrella.[2]

As one can see in this example, Fry is not totally formalist in his approach and even speculates on Daumier's intentions. But his emphasis is on the relationship of the forms of the picture and not its relationship to nature or its verisimilitude to nature. He would probably not have approved of a totally nonobjective art; he relied in his critiques on a dialogue between the formal construction of the work and the reaction the artist made to natural phenomena. All the artists that he supported were representational except for Kandinsky. According to Fry, it was the purpose of the artist to eliminate the nonessential and distill its significant form.

Another indication of his belief that artists should start with an interpretation of nature is his ideas on drawing. Fry believed that drawing should consist of a balance of drawing from life and drawing abstractly from within the mind. Great art contained both, but he had particular objection to the one-sided naturalism of impressionism because he felt that because of its almost total reliance on nature it lacked a conscious structural design.

Fry's taste was characterized by a love for simplicity and structure in a representational work of art. He preferred artists who painted solid and recognizable shapes. He disliked the chiaroscuro and the dramatic light effects of the Baroque period and admired the simplicity of the Italian primitives. In particular, he disliked the art of the medieval period, which he believed to be almost totally concerned with literal depiction and indifferent to the idea of formal composition. He also believed the art of classicism was also too involved with the literal and often unimaginative.

Although Roger Fry sought to eliminate literalness or dramatic subjects from painting he could never totally resolve this issue in his career. At the end of his essay "Retrospect," he claimed that the dramatic component, the literal story of a painting was unnecessary and interfered with the aesthetic appreciation of significant form. Later, in a lecture titled the "Double Nature of Painting," given in 1933, he proposed that the two could be compatible. It was for Clement Greenberg and other critics of High-modernism to develop a theory of art that would support the idea of a totally nonobjective art.

Roger Fry's contribution to the development of modernist art theory centered on his influence in popularizing formalistic criticism. As an art historian he correctly placed Cézanne as the most important artist of his time. His theory of excellence in art made it impossible for him to see much value in medieval art. Although he tended to dismiss much of classicism, he praised the work of those artists who he believed possessed a feeling for significant form despite the literalness of their subjects (e.g., Leonardo and earlier masters). Major artists of the Baroque, such as Caravaggio, were criticized because their style deviated from his preference for simple and essential representations.

A problem with Roger Fry's theory of excellence in art centers on the concept of "significant form." The term is critical to the theories of both Fry and Clive Bell, whose notion of "significant form" is a characteristic common to all great art. Unfortunately, this term was never adequately defined by either author. It is a mystical essence known primarily by what it is not. It is not the subject matter of a work or its literal references but rather an essential element. This essence has the potential to produce an aesthetic experience in an attentive viewer. It is therefore a mystical concept that seems more in keeping with Plotinus and Neoplatonism than the scientific and empirical emphasis that characterizes much of the rest of Roger Fry's writing.

As a theorist, Roger Fry offers us a lesson on formalism. He was not only one of the first critics to use a thorough analysis of the formal organization and technical execution of an artwork in his criticism, and yet his best criticism is that in which he is least formalist and includes contextual considerations. He did this with his critique of Cézanne's work; he understood the important circumstances of the artist's life, his intentions, and his reaction to contemporary trends.

The formalism of Roger Fry is quite different from that of Clement Greenberg. Fry's differences with Greenberg are varied and distinctive and yet are mentioned rarely in discussions on formalism in Postmodern literature. Fry was largely responsible for popularizing the

formalist approach to art criticism that Greenberg later adapted as his own. But his formalism was different, less absolute and ultimately more friendly to Post-modernism's position on a broader definition for artworks. While both men emphasize the abstract qualities of form and formal organization in evaluating artworks, only Greenberg's approach is dogmatically apolitical and in large part uninvolved with many of the external or contextual aspects of the work. Fry's best criticism is that in which he offers a formal analysis that is balanced with considerations of time and place.

Other differences with Greenberg concern Fry's reliance on nature as a source for art. Greenberg's belief in the inevitability of modernism's evolution to Abstract Expressionism would find little support in Fry's ideas on art. It is interesting to speculate on how modernism might have developed had Fry remained influential during the mid- and later twentieth century. Fry in his critiques relied on a dialogue between the formal construction of the work and the reaction the artist made to natural phenomena, whereas Greenberg endorsed a totally nonobjective art. According to Fry, it was the purpose of the artist to interpret natural phenomena, and in the process to eliminate the nonessential and distill its significant form, not to eliminate the subject matter entirely.

The idea of a flatly painted surface characteristic of Abstract Expressionism and Greenberg's prescriptions would also find little support. Fry states in *Transformations*, "It is doubtful a purely flat surface without suggestions of significant volume, can arouse any profound emotion."[3]

What is of particular interest today is Fry's global focus as opposed to Greenberg's Eurocentricity. In his unfinished lectures given at Cambridge as Slade professor and published posthumously as *Last Lectures*, Fry set himself the task of a historical survey including the art of Egypt, Africa, India, Greece, and Rome. The work is important in two major ways: it illustrates his transcultural appreciation for art, and it shows his broad interpretation of what can and cannot be considered great art. Fry introduced two new terms to his lexicon, "sensibility" and "vitality." Sensibility referred to the execution of the work and vitality had more to do with the plan and design of the work. Using these new critical tools, he argued that African sculpture was superior to classical Greek and Roman sculpture because it had greater vitality.[4] In addition, any artifact, from a painting or sculpture to a ceramic cup or Chinese bronze, was treated as a worthy candidate for aesthetic appreciation. There was no categorical separation of popular

art from high art as with Greenberg but rather an inclusiveness and cultural egalitarianism.

Roger Fry's aesthetic theory, as well as his aesthetic tastes or criteria for excellence, was not without its faults. Although his formalism was not dogmatic or absolute, he did grossly misunderstand much of non-Western art, failing to learn about its religious and symbolic meanings. This last point, though grievous in today's world, was more understandable in Fry's time. This does not mean that formalism cannot be useful in analyzing an artwork, only that there is an inherent weakness in the approach. If overly or dogmatically emphasized it leads to an underawareness or unawareness of the context of the work. The purposes and intentions of the artist and a whole range of considerations that lie outside the artifact of the artwork seem of little consequence to a strictly formalist analysis of its physical properties. The most obvious argument against an absolute formalist position is, of course, that it is dependent on training in the principles of design. Harold Rosenberg, whom we will later discuss, represents something of an antithesis to a materialist and formalist orientation. An absolute emphasis on either aspect of an artwork—the physical artifact or the contextual aspects of the work—limits both the understanding of the work and its aesthetic appreciation. With the best art theorists and critics (those most influential in the history of aesthetic experience and artistic creation and appreciation), there is always a double emphasis, a tension between the art of space and the art of time (to use Lessing's division in the *Laocoön*); a tension between the world of matter and mind, atoms and ideas. In addition, Roger Fry's broad definition for fine art or high art is in stark contrast with Greenberg's premise that fine art includes only works that are the natural evolution of a modernist school of Paris. It is clear that Fry's formalism, had it remained predominant in the modernist theory of the mid-century, would not have led to the Post-modern backlash caused by Greenberg's extreme definition of fine art.

Critics at the beginning of the twentieth century ranged from those who still followed the rules of academic classicism, to those with Romantic and modernist leanings. Despite theorists' orientations, more emphasis on analysis of the formal arrangements of artworks were included in their critiques. Modernist critics in France such as André Salmon and Guillaume Apollinaire were also influenced by the symbolist movement in poetry.

Symbolism was a Romantic and idealistic movement in literature, beginning in the late nineteenth century, that supported the idea that

there was a distinction between the visual reality that we can perceive and the truth behind those appearances. The idea of symbolism was in agreement with the philosophy behind Cubism, and those critics, among others, became supporters of the new movement in the visual arts that also sought a separation from literal nature. These critics believed that artists, like poets, should have the freedom to experiment with their man-made cognitive constructions or symbols with the hope that this experimentation would lead to uncovering an ideal reality. This linking of the two art forms, poetry and the visual arts, was prompted in part by Baudelaire's influences on symbolism and his theory of "correspondences." In this, he stated that one must look through the appearance of things, everyday objects and events, to understand the ideal nature beyond. He believed that the arts were interrelated and must seek to produce these correspondences with the ideal.

Avant-garde modernists such as the Post-impressionist Gauguin and Van Gogh were influenced by symbolism and sought to use abstract colors and forms to express emotions. The Cubist movement, begun by Pablo Picasso and Georges Braque in 1907, took the idea of symbolism further and, in the process, continued modernism's evolution away from literal interpretation toward further abstraction and formalism. This Romantic speculation on the power of symbols begun by Baudelaire should not be confused with Post-modern European symbol theory, which is based ultimately on the work of Swiss linguist Ferdinand de Saussure (1857–1913), and is unconcerned with evaluating physical artifacts but rather with describing how words function as symbols or referents bearing references. The Romantic movement known as Symbolism was more concerned with the transcendent and universal than the process of personal symbol functioning essential to Post-modernism.

Visual art theory in America was slower in developing than it was in Europe. Part of the reason for this was the lack of a large art-going public in America until the late nineteenth century. At this time, magazine and, later, newspaper criticism began to appear. Art criticism began to be published in Sunday editions of newspapers around the turn of the century.

The ideas of John Ruskin were the first to dominate American art criticism. This was probably because there was no language barrier and the fact that the American people shared with the British a desire for an ethical purpose for art. Early newspaper critics such as Royal Cortissoz (1869–1948), who wrote for the *New York Daily Tribune* (after 1891), still supported academic classicism. Others, like James

Gibbons Huneker (1857–1921), who wrote for the *New York Sun*, were supportive of modernism. Edward Alden Jewell (1888–1948), who wrote for the *New York Times*, supported American regionalist painters such as Thomas Hart Benton and Phillip Evergood. These artists contained aspects of European modernism but were more realistic, political, or moralist than the more abstract and experimental modernists such as Picasso, Matisse, or Miró. There were critics and theorists who supported the French avant-garde, but most American critics active in the 1930s and 1940s preferred a semiabstract or realist idiom. This preference shifted dramatically with the writings of Clement Greenberg and the start of the Abstract Expressionist movement in art.

21

Clement Greenberg

Clement Greenberg (1909–1994) was a formalist art theorist, but many of the theorists of the 1930s and 1940s were, to a large extent, formalist in their methodology. The difference between Greenberg and other critics of his generation was his total apoliticism and his dedication to a single evolutionary criterion for excellence in art.

Clement Greenberg believed that the visual arts should follow the tradition of the school of Paris. He considered Matisse, Picasso, Miró, and Mondrian the prominent artists of the twentieth century. It was the role of avant-garde artists to carry on this tradition by extending Cubism into a purely abstract art.

In his famous essay "The Avant Garde and Kitsch," Greenberg expressed many of his key ideas. With the beginning of the avant-garde in the nineteenth century, artists emigrated from bourgeois academic society to Bohemia, a social state outside this larger society, to pursue art for its own sake. Greenberg believed that the artist maintains a higher level of art by avoiding the marketplace or the aristocracy. Instead, artists separated themselves from bourgeois society and its values and also began the process of separating art from its subject matter, concentrating on formal properties. They began to let the media in which they were working dictate the nature of their forms and colors. According to Greenberg, major artists such as Picasso, Braque, and Miró derived their inspiration from the medium that they worked in. He stated, "The excitement of their art seems to lie most of all in its pure preoccupation with the invention and arrangement of spaces, surfaces, shapes, colors, etc.; to the exclusion of whatever is not necessarily implicated in these factors."[1]

Greenberg described the artist as a new kind of dandy, not necessarily an intellectual, but someone stoic, courageous, and arrogant. He believed that arrogance and commitment to painting may be the greatest attributes of the artist. He stated, "The great artist must be arrogant, even ruthless; his work flows from something contented and sensuous, we respond to it when we are most confident about ourselves."[2]

Avant-garde culture produces art that is original, creative, vital, or stimulating. Modern industrial society has also produced an inferior culture that he calls "Kitsch," the German name for the popular commercial art of magazine covers and Hollywood movies. Kitsch is a parasitic culture that feeds off the real developed cultural tradition. It exploits the weakness of human beings, their sentimentality, lack of education and sensitivity, and their laziness.

Kitsch was thought to be a problem in modern society partly because industrialization had transplanted people from the country to the cities. This caused them to lose their folk cultures and made them susceptible to a false art that would be accessible and pleasant. Kitsch art was, by definition, uncreative, mechanical, and produced by formulas. In his essay he gave two examples of Kitsch painters: Repin, the Russian social realist, and Norman Rockwell, the American illustrator. Both men, according to Greenberg, chose to cater to the masses and create trivial work.

Greenberg believed that the majority of people were often unable to understand the value and importance of avant-garde art. He believed that this was because people have always had difficulty appreciating art that is abstract and requires interpretation. In contrasting Picasso's art with Repin's, he believed that the latter's popularity in Russia and Rockwell's in the United States was based on the fact that their art requires nothing from the viewer. They merely tell a pleasant story and require no interpretation. The work of Picasso is another matter, in that it often requires reflection on a first impression of its formal properties.[3]

Greenberg also warns that Kitsch can be used by dictators, like Hitler and Stalin, to indoctrinate people because its attractiveness promotes a passive acceptance of totalitarian beliefs. This last idea is important because it means that avant-garde art must remain apolitical. Andreas Huyssen called this period of modernism "high modernism" and associated this renewed sense of apoliticism with the critical writings of Greenberg and those of the German literary critic Theodore Adorno.

Greenberg surmised that if art was apolitical, dealing only with formal beauty, it would appeal to reason as opposed to mankind's baser emotions.

The history of modernism was arguably both political and aesthetic. For example, movements such as Dada, Constructivism, and Futurism were political and egalitarian and dealt with mass media. It would be difficult to see any separation from popular arts or Kitsch in these movements. Greenberg's vision of modernism or high modernism emphasized art and artists that pursued formal goals only. He saw artists pursuing political aims as reactionary.

As an art critic, Clement Greenberg wrote in a style that was simple and direct, more like Ernest Hemingway than the poetic styles of Baudelaire, Ruskin, or Greenberg's contemporary, Harold Rosenberg. For example, in discussing the paintings *She Wolf* and *Totem I* by Pollock, he stated, "Pollock cannot build with color, but he has a superlative instinct for resounding oppositions of light and dark, and at the same time is alone in his power to assert a paint-strewn or paint-laden surface as a single synoptic image."[4]

Greenberg was a formalist to the extent that he discussed individual artwork without necessarily relating those visual qualities to the personal or psychological motivations of the artist or their society. But behind this formal emphasis and materialist learnings is an objective Idealistic and evolutionary theory of art. His theory that great art comes from one source and that it must by necessity evolve over time was based in part on Marxist political theory. Since the philosophy of Marxism states that forms of governing must inevitably evolve into communism, it would follow that this form of absolute evolution should occur in the world of art. Greenberg's theory is an unusual mixture of a Marxist material emphasis and an interest in a spiritual and transcendent aesthetic experience. His emphasis on the notion of the impersonal forces of history determining art is similar to Taine; while a Positivist and deterministic thinker, his concerns were also centered on a universal and objectivist overview of art history.

The product of the individual psyche was not important as a source of art, according to Greenberg, rather what was of central concern was how individuals responded to the avant-garde ideas of their time and the physical processes used to create art. Contemporary artists not working in the avant-garde style were relegated to the rank of minor artists. This was particularly true with the American regionalists who were popular among many critics when Greenberg began writing in the later 1930s. It was also true, although to a lesser extent, with his assessment of artists like John Marin or Mark Tobey, whom Greenberg appreciated but also felt were transitory. Artists who were surrealists or synthetic Cubists working in the 1940s and 1950s were seen as

failing to tap into the present spirit of the age. The success of Abstract Expressionism during the 1950s owed much to the influence of Greenberg and thus many of the works of regionalist and surrealist artists were less known and shown. Overall, he contributed greatly to the success and acceptance of Abstract Expressionism and influenced the development of art in this country and throughout the world.

Clement Greenberg primarily emphasized the importance of an independent and transcendent aesthetic experience with art. He described this experience in the characteristic manner as one that is immediate and concerned with feelings rather than intellect, based on experience rather than reflection.[5] This aestheticism presented problems when he periodically was aesthetically moved by work that did not fit into his evolutionary theory.

One example of this tension in his criticism is shown in a review of a painting by Gorky that he believed to be reactionary. He acknowledged that he appreciated the "elegance of the painterly style," but "would rather the artist work with greater resolve and purity even if these qualities were lost."[6]

Clement Greenberg's approach, although aesthetically based, often failed to adequately consider all the contextual information necessary for making adequate evaluations of artworks. The psychological reasons that an artist created a work were of little importance to him. This is particularly problematic when he critiqued artists like the surrealists, whose individual psychological motivations played a monumental role in determining their art. He is, in fact, critical of them for creating work that is too personal, literal, and reactionary.

Clement Greenberg's limitations as a theorist were most pronounced when he specified the need for artists to work within one established approach or style and failed to give proper credit to the uniqueness and individuality of artists, as well as to a variety of traditions of artistic creation active and vital at any period in the history of art. A study of history suggests that at any one time or period there may be many legitimate styles and major artists working within those styles. Greenberg's theory does not acknowledge this as a possibility.

Greenberg's division of art into two categories, high art and Kitsch, also does not adequately explain the political art of the past. It can be argued that all art is political in the sense that it makes a case for what is valuable in art and what is not. But more overtly, much of the art of the past generates perceptions concerning politicism, morality, and manners. For Greenberg, the fascist threat and his communist roots made his acceptance of political art impossible. Art was intended to re-

turn to a revived sense of art for art's sake and to become pure to the extent that it made no specific political statement. The irony of this is that Abstract Expressionism, when contrasted with Russian social realism during the cold war of the 1950s, was viewed as an expression of the freedom allowed in a capitalist democracy.

Greenberg's definition of high art fails to include much of modern contemporary art. It also leaves one to wonder whether there are gradations of Kitsch or high art. How does one regard great movies, for example? According to Greenberg they are, by their nature, Kitsch—but are they great Kitsch or great art? A simple dichotomy cannot adequately accommodate these examples.

Clement Greenberg was no doubt one of the most important and influential art critics of the twentieth century, but he does not represent the totality of modernist theory. It must be understood that his interpretation of modernism was specific to him. It is also arguable that his influence on the historical development of modernism went beyond his role as art critic and that he helped orchestrate its progress. Greenberg's narrow definition of fine art (that it only included painting and sculpture) and his apoliticism has been predominantly responsible for the Post-modern backlash still in vogue. But Greenberg's dogmatism not only fueled Post-modernism's politicism but oddly contributed toward Post-modernism's dogmatic materialism. I say oddly because on the surface one would think that Greenberg's aestheticism would have contributed to a continuation of this concept in Post-modernism, but the opposite seems more accurate. As noted earlier, Greenberg's ideal artist acquires inspiration from the materials of painting itself and the tradition of modernism, rather than through a transcendent and divine nature or the use of a spiritual imagination. Although one can infer in Greenberg that there is an objective and transcendent reality that determines great art, it is based solely on the predetermined qualities of visual matter itself. Whereas his view of the artist as being street-smart and arrogant in the face of the masses and the uninformed has been largely appropriated by many Post-modern theorists and critics, his evolutionary theory and his aestheticism has been soundly dismissed. Greenberg's aesthetic focus has been replaced by the concept of the artist as a social critic or personal commentator on cultural conditions. Only extra-aesthetic goals and objectives are considered meaningful. As we have previously stated the role of Post-modern artist as social critic is hypocritical in an art world based on promotion and profit.

A reaction to Greenberg's aestheticism and an acceptance of his materialism has led to a state of dogmatic materialism in Post-modern

theory. In Post-modern theory there is a denial of belief in transcendence and a dogmatic refusal to leave open the possibility of such belief (transcendence meaning those concerns that deal with the possibility of belief in God and with universal themes that reveal human nature and thus transcend particular political rhetoric). This growing relativism denies the possibility of shared experiences and mutually beneficial beliefs. These factors have resulted in unduly narrowing the focus of much of Post-modern art. It has made this art gender, race, and politically specific instead of universal in its appeal.

It is the role of art education to look again at the Post-modern reaction to High-modernism and Clement Greenberg in particular. Was an almost total denial of his aesthetic theory necessary? It seems that Greenberg was continuing in the tradition of aesthetic consciousness that has existed since classical times, and yet this aspect of his theory was dismissed along with his dogmatic ideas concerning the avant-garde and Kitsch.

22

Art as Political Rhetoric

The idea that art is a form of political rhetoric is unique to Post-modern theory. This concept and its antiaesthetic ramifications have contributed to further separating Post-modernist art theory from modernist art theory, and indeed all other forms of art theory (Western and non-Western). Although the political dimension of Post-modern theory was on the rise in the 1980s and 1990s , the idea that the arts are effective as political rhetoric has always been questioned. For example, Danto questioned whether art changes attitudes at all.[1]

The effectiveness of the arts as political statements brings one to the more fundamental question of what the nature of art is and what these artifacts are used for by different cultures and peoples. Artwork's political dimension can be understood by considering all artworks political and persuasive. All artworks can function as rhetoric and yet remain primarily aesthetic objects. Post-modern theory has ignored these distinctions.

Every artifact created can be said to have meaning or meanings, but it is not clear that artworks are valued for their reference to ideas and concepts. Artworks function quite differently than conventional symbols such as those in mathematics or language. We can use the number 5 when we do mathematical calculations and be confident about the clarity of its reference and meaning, but a painting, *The Figure 5*, by Charles Demuth, presents us with multiple and ambiguous references and meanings. Its meaning is difficult to know with clarity and is not conventionally known or understood. It is doubtful that people value Demuth's painting for its reference to the number 5 or the efficiency of its symbolic functioning.

Using a Post-modern example of the same situation, a work that is intended primarily for a political message such as Judy Chicago's *Dinner Party* conveys a multitude of meanings, some intended and others accidental. A feminist could express these ideas more clearly and effectively by writing a manifesto than producing a persuasive sculpture, painting, photograph, or poem. Despite these arguments, an acceptance of art as rhetoric has been established in Post-modern thought in part as a reaction to Clement Greenberg's apoliticism and aestheticism.

23

Harold Rosenberg

The other major theorist and critic of Abstract Expressionism was Harold Rosenberg (1906–1978). His approach to art criticism was quite different from that of Clement Greenberg. His lack of interest in the material aspects of art was central to his theory. He stated, "The arrangement of colors and forms on the canvas never encompasses completely the experience that moved the artist to execute it and the painted surface is always in some respects nothing more than a thing."[1] Rosenberg emphasized the thinking processes that an artist used to make a work of art instead of a concern for the artifact or materiality of the artwork.

According to Rosenberg, the critic should reveal the personality and thought processes of the artist and not be limited by the artifact of a work. He believed that the critic should not only describe and evaluate art but should choose a mode of insight with regard to that work that would best explain the thought that created it. This mode could be aesthetic, psychological, social, or metaphysical. Despite this mention of the aesthetic, it is clear that Rosenberg was not a supporter of the concept of an autonomous aesthetic experience that was necessarily connected to a physical artifact. Rosenberg's art theory at its core was concerned with the process of accumulating knowledge through mass media, and he rejected the idea that an artwork is necessarily physical or need have a physical reality.

The idea that a visual art critic should be concerned about the thought of the artist as opposed to internal aspects of the artifact is of course not new. It was, generally speaking, the approach critics had prior to the emergence of formalism in the late nineteenth century. Vasari and Bellori, for example, addressed a painting in a predominantly literal manner

by "reading" its story and evaluating it according to the tenets of classicism and on how well it successfully communicated the meaning of a biblical or mythological story. With few exceptions, the decorative or formal qualities were seldom mentioned. Critics mainly described the personalities of the artists they wrote about. It took a long period of development to establish the idea that it was important for critics to concentrate on the purely formal aspects of an artwork.

With the rise of the science of archaeology in the nineteenth century came an awareness that a more careful study of the history behind events was necessary to help ensure accuracy. Early archaeologists such as Hippolyte Taine, for example, believed that art should not be studied independent of its causal forces. The most important considerations for art were its origins in the classification of race, environment, and movement.

The creative event was the living aspect of art for Rosenberg. He did not share Greenberg's belief that art followed an inevitable evolutionary process or that the critic was in a position to see into the future of art. The critic, he believed, was occupied in describing the art of the present with information from the past. The critic described an unfolding event, a political or cultural drama in a world in the process of reworking itself. For Rosenberg, an apolitical art was impossible.

In *Art on the Edge*, Rosenberg makes a case for the uniqueness of contemporary art. He states, "That with change established as the norm of present day life, the capacity for innovation and recasting old art into new forms has become a primary virtue of art."[2] He believed that art had become totally different from any previous period because of the influence of mass media and the proliferation of imagery from past styles. Modern art was also unique because it was not dominated by the need for the mastery of a craft as previous periods had been, and therefore it was freed from these requirements to become more involved with thought and ideas. This anticraft idea has become a cornerstone of present Post-modern art theory.

According to Rosenberg, an artist who epitomized this shift in emphasis was Barnett Newman. Rosenberg writes, "Newman may be appreciated as a 'mystic' through whose canvasses the onlooker levitates into cosmic pastures where emptiness and plenitude are the same thing."[3]

The evidence of the intellect in Newman's art was, for Rosenberg, its denial of all art before it and its singularity and ripeness for emotion. It was the ultimate art since it was not an example of formal arrangements but rather a creative consciousness put on canvas. It was not about the craft of painting but about thought.

Rosenberg's notion of the artwork shares similarities with many of the ideas of contemporary philosophers, such as Arthur Danto and George Dickie, in particular, the idea that an artwork's ontological status is not determined by the artifact alone, but is concerned with the notion of interpretation, artistic customs, and practices. Danto's famous example of a shovel in an exhibition being considered an artwork, while a duplicate shovel a few feet away in a gallery closet is not, echoes Rosenberg's assessment that art cannot be equated with its object.[4] To these theorists the external factors of the work and especially the meaning of the work in the context of artistic practices is paramount in determining its status as artwork.

Post-modern criticism is indebted to Harold Rosenberg for his repudiation of formalism, his interest in the political content of art, his acceptance of multiple styles in contemporary art, and his anticraft requirements.

Harold Rosenberg's criticism fails to be about aesthetic theory because he did not sufficiently emphasize the aesthetic experience with the visual artifact of the artwork or differentiate it from logical thought. The fact that he did not address the question "Why do the internal properties of the artwork produce an aesthetic experience?" but dealt with the visual arts as an aspect of thought, prevented him from being an aesthetic theorist. Rosenberg's allegiance to thought over artifact can be clearly seen in his essay "On Impermanence in the Visual Arts." In this essay he refers to Lessing's separation of the arts into the arts of space and the arts of time to make a distinction between Highmodern and current views on impermanence in art appreciation. He uses the French Catholic philosopher Etienne Gilson to represent the older emphasis on space over time. He states, "A painting is of time when it is considered as an encounter between the artist and his audience. It belongs to space when it is considered as a thing, that is to say, as Gilson puts it, 'from the point of view of the work of art itself.' "[5] Rosenberg believed that thinking of art as a transcendental "artifact" was an outdated concept, "a fixated aestheticism of Dorian Gray."[6] For Rosenberg, movements in twentieth-century art such as Action Painting and Happenings prove that artworks did not have a meaningful physical existence. He also believed that the notion of aesthetic contemplation was a worthless gesture for a dead art. The most typical art experience for Rosenberg was perceiving mass-produced images of artworks; it was not contemplative but rather "circulative." Art books in particular were substitute images, which had the added benefit of being explained or described, whereas the direct experience of art

contributed to no more than a lively sensation of ignorance.[7] Art, according to Rosenberg, was characteristically a document, that could be read like a book. For him the idea that one would contemplate a work isolated from the context of knowledge, and attend to the artwork aesthetically was inaccurate. He believed that people's understanding of a painting was almost always through secondary sources. He stated, "But while the painting is supposed to speak, it has become nothing else than what is said about it."[8] Rosenberg endorsed the view that art was a timed circulation of ideas, not a physical reality, and that a traditional aesthetic viewing of these objects would be of dubious value to people. As he stated, art books are better suited to satisfy human beings' appetite for knowledge than the works themselves.[9] He does make the concession that for a complete education in art one would need a direct exposure to the original works, but he was uninterested in developing these ideas further.

Rosenberg's emphasis on art as idea and not artifact is, of course, the view that governs Post-modern theory. Both Structuralism and Post-structuralism, as well as modern analytical philosophy, disregard the concept of art as a transcendent artifact. This idea has become widely endorsed despite the fact that masterpieces of art become so in part because of their popularity or ability to please people of various cultures and ages.

By adopting the ultimate outcome of a Kantian metaphysic, art cannot have an objective existence. But are the visual arts so easily assimilated into the conception of a rational symbol or system of acquiring knowledge, as Harold Rosenberg believed?[10] As discussed earlier, this marriage remains problematic.

Rosenberg's art theory is also problematic because it is unable to accept even provisionally an existence of a physical and transcendent artwork or masterpiece. Whereas earlier twentieth-century philosophers, most notably John Dewey and Susan Langer, allowed for intuitive experience, or the necessity for direct experience with the artifact of an artwork, Rosenberg and current Post-modern theory do not.

It would be hard for one to imagine Alberti, De Piles, or Diderot abandoning the importance of the visual artifact as Rosenberg did, because their experience with art stemmed from a different and less dogmatic metaphysic. Rosenberg contrasted his ideas about art with images of a dogmatic past where "aesthetics contemplate paintings in dark churches" (no doubt an allusion to Vasari).[11] But is this entirely a fair comparison; is such a stark dichotomy possible when aesthetic contemplation continues to be practiced by practically everyone? To

think otherwise would be elitist, presumptuous, and dogmatic. To truly search for knowledge one must use those faculties that can lead one to a broader knowledge than a Kantian metaphysic would allow.

Contrary to Rosenberg's allusion to a dogmatic past, his omission of the role of aesthetic experience in art has led his artistic theory to be both dogmatic and elitist. To truly search for knowledge as Rosenberg desired, one must use those faculties that can lead one to a broader knowledge than he himself prescribed, or than a Kantian metaphysical position allows.

24

Post-Modernism: Anomaly in Art Critical Theory

Post-modernism is an anomaly in the history of art theory. It can be thought of as antiaesthetic and is, in part, based on questionable and not thought out premises. Post-modernism was created as an antithesis to a modernist aesthetic emphasis. It interprets the modernist phrase "art for art's sake," in the most narrow and materialistic sense. This conscious antiaesthetic makes many Post-modern artworks uniquely unsuited for aesthetic evaluations. The Post-modern appropriation of questionable beliefs and the reaction to other beliefs has also contributed to producing an art that is primarily about meaning and not value, political rather than aesthetic. It is literal and materialistic—not visual and transcendent. This has been done by establishing in Post-modernism the belief in the concept of the artist as rebel and social critic, believing that art is primarily political rhetoric, losing sight of the aesthetic link between art and the individual, and establishing a state of dogmatic materialism and relativism with regard to the sources and subject matter of art. Why consider Post-modernism an anomaly? It is necessary to look at the genesis of this mode of thought and how it appropriated, rejected, altered, and ultimately misunderstood aspects of modernism.

The term "Post-modernism" refers to that movement in the arts following modernism and usually described, in the visual arts, as beginning with the Pop Art movement of the 1960s and continuing to the present. Post-modernism is a movement in all the arts and can be thought of as a reaction to and denial of High-modernism. It is a diverse philosophical movement most characterized by the appropriation of images from mass culture, as well as from past periods of art, often with a concurrent politicizing of the imagery. The separation of

"high art" from commercial art and popular art is eliminated and there is a sense of equality of all art forms and sources.

Post-modern art theory is characterized by a denial of the validity of a formalistic evaluation of art. Post-modern critics emphasize the contextual meaning of a work of art and often elucidate its personal or political meaning. Many Post-modern critics believe that High-modernism had become restrictive, elitist, conservative, sexist, or out-dated. Speaking from a Post-modern point of view, Huyssen believed that the premise of High-modernism (the separation and apoliticizing of fine art) was made unnecessary by the failure of fascism. He added that Theodore Adorno's similar fear that capitalism would exploit and manipulate people has also proved unfounded, since mass culture is chaotic and lacks the monolithic character necessary for dictatorial control.[1]

Post-modernism seeks to be more inclusive of populations previ-ously excluded from the Western art world. This includes minorities and women. There is also a greater involvement with non-Western art and folk arts. Under the label of Post-modernism, the definition of fine art has been expanded to include a range of artifacts not previ-ously considered art.

Art is also not considered, as it was in modernism, a truly original expression. The Post-modern view de-emphasizes originality and em-phasizes the notion that the availability of images in modern culture has made everyone influenced by others. Because one cannot truly create, it is the function of the artist to appropriate.

The purpose of art can vary widely in Post-modernism. An artist has the freedom to promote a well-defined political agenda, such as world peace, the need to eliminate disease or poverty, or women and minority issues. Other artists can use humor to express their political ideas. Still others emphasize self-promotion and concentrate on self-indulgent themes. Andy Warhol is an example of this final group. In general, craftsmanship has become passé and issues of deconstructing language and attacking a perceived patriarchy have become a formula for success in both college programs and the art world in general.

Post-modernism is not evolutionary, like modernism, and is thought of as diverse and having little coherent structure. It remains unified in its interest in appropriating the past. Eclecticism, self-consciousness, and appropriation of images are the norm. It has also given new oppor-tunities for previously unpopular styles and movements such as the Pre-Raphaelites to be reconsidered. This and other forms of sentimen-tal realism have influenced artists such as Audrey Flack. A previous

modernist movement, German Expressionism, has been appropriated and changed to become a movement called Neo-expressionism.

Post-modernism is not a universally accepted concept by many critics active in the 1970s, 1980s, and 1990s. Many contemporary critics hold to the tenets of modernism and find Post-modernism to be symptomatic of the decline of our civilization and standards of excellence. Hilton Kramer is one such critic who has expressed this view.[2]

Post-modernism has been accused of being self-indulgent, narcissistic, and uncommitted by critics who generally support modernist views; however, it is not without social interest and responsibility. Huyssen states, "If pop art has drawn over attention to the imagery of daily life, demanding that the separation of high and low art be eliminated, then today it is the task of the artist to break out of art's ivory tower and contribute to a change of everyday life."[3]

As we have discussed earlier, an emerging social consciousness begs the question whether art can be an instrument for political or social change. Danto believed that art rarely changes attitudes but rather mirrors attitudes already in place. It memorializes these causes but does not recruit new members.

Whether art is an effective social tool or not, many Post-modern writers believe that art should be socially conscious in order to be a vital and accurate expression of contemporary society. In Erika Doss's study of Thomas Hart Benton and Jackson Pollock, she concluded that High-modernism caused a moral breakdown of the art world of the 1950s.[4] Her premise is that the separation of art from the social issues of the day, such as desegregation and racism, was a political act conducted by business interests for the purpose of silencing social unrest in American society.

If one makes the case that High-modernism was morally irrelevant, and that Post-modernism is ultimately a reaction to a lack of social consciousness, then Post-modernism is only a reaction to High-modernism and not to the tenets of modernism itself. Unfortunately Post-modern theory has become antiaesthetic. The concept of the creation and appreciation of art being distinct from cognitive thought has been lost, and a new sense that art is a form of rhetoric has been established. In particular, Post-modern theory has been concerned with casting doubts on modernist tenets such as the idea that artists and artworks should seek to be original. Rosalind Krauss, for example, stated that originality and repetition are a doublet, a paired opposition, never distinct or separate in the reality of artworks.[5] In other words, there is no absolutely original art. She believed that modernism mistakenly

gave priority to the term originality and tended to suppress the notion of repetition or copy. In giving the example of Rodin's *The Gates of Hell*, she showed how far removed this modernist artist was from creating a truly original work of art. Rodin never concerned himself with his bronze castings, preferring them to be done without his supervision. His *Gates* was assembled from plaster fragments in his studio at the time of his death and only cast years later. In this sense, there was never an original *Gates of Hell* and what exists are only copies. Krauss also notes that the "grid" form so popular during modernism is hardly original and can only be repeated without knowledge of an original.

Post-modern art theory has given to the field of art criticism a philosophical emphasis. Post-modern critics show an increased implementation of interdisciplinary thought and study, making reference to work in other fields such as linguistics, anthropology, sociology, and the behavioral sciences in their work as critics.

Post-modern theorists are predominantly contextual in their approach to criticism. There is an emphasis on the external properties of the work, as in the criticism of Harold Rosenberg. They may consider judging art to be the least important aspect of their critical work; their emphasis is on the interpretation of an artist's work and helping the reader to understand the ideas and emotions evoked by the imagery. Lucy Lippard, for example, in critiquing the work of Andres Serrano, was primarily concerned with the idea that the artist was an important social critic and she spent very little time describing the qualities of his photographs.[6]

It is the antiaesthetic nature of Post-modernism that has threatened to trivialize art education by assuming that aesthetic experience is outdated or nonexistent. It is this antiaesthetic position that needs to be addressed in art education rather than its unquestioned acceptance.

25

Feminist Art Criticism

Many Post-modern theorists are committed to promoting art that will speak for women. They are concerned that women have not been fairly represented in the art world, and that the unique and often oppressive conditions that women face in society are not addressed. They object to a variety of issues, such as the notion that creativity is masculine and the use of women in art as a subject of physical attraction for men. Their role as theorists is to interpret art in terms of feminist issues and to promote art that will serve to express women's unique situation in a male-dominated world. Many feminist critics have an overall goal to empower women in society and in the art world in particular.

The feminist critic Cassandra L. Langer makes a distinction between being merely feminist and aware and being actively involved in revolt against a sexist society. Some conservative feminist art historians have tried to incorporate missing women artists into the existing history of art; however, she believes that a gynergenic critique of art history and art criticism needs to be applied.[1] This gynergenic critique is an aggressively woman-identified attack on the male status quo. It attacks the history of art and the standards for excellence in art that have been shaped and defined by men. A different standard of measurement needs to be applied that is based on the existence of a distinct feminine sensibility.

She believes, in particular, that male art historians have perpetrated falsehoods to gain sexual domination for male artists. An example is the notion that men originate ideas and that women are only able to follow them; thus, that Mary Cassatt was only a pupil of Degas but in reality that relationship did not even exist. The notion that artists such as Cassatt painted maternity scenes because they had an instinctive

need to become mothers is also considered a distinctly male notion. Art should be reevaluated from a feminine perspective; this includes the art of the past that was created by both men and women.

Joanna Frueh, another feminist critic, does not believe the feminist perspective will replace traditional art historical methodology; rather, the inclusion of the female point of view in art will complement and amplify the old with a fresh analysis and interpretation of style and iconography.[2] In her analysis of Gustave Courbet's *The Source*, one sees an example of this feminist perspective:

> All in all, woman (the nude in the painting) symbolizes fe-
> cundity and lack of consciousness. But who is this nude?
> She is the single, anonymous woman who represents all
> women, not as a social group, but as woman-female of the
> species in one aspect of the eternal feminine: Earth mother/
> Mother earth. This myth of women is not necessarily
> repugnant. However, it is only a fragment of reality, an ide-
> ology through which we should not expect to see what any
> individual woman genuinely is.[3]

Many feminist critics believe that there is a need for women critics to interpret women's arts, as well as reappraise men's art. Important subjects in art that need particular attention are eroticism and maternity subjects, because the manner by which these subjects have been dealt with by men in a male-dominated society has supported a sexist status quo. Nudes, for example, are often used for the purpose of male sexual titillation or to reinforce the image of male superiority.

Feminist art critics have often blamed modernism for helping to create an art world that is paternalistic, homophobic, elitist, Eurocentrist, and antifeminist.[4] In their haste to react to High-modernism and particularly the perceived sexism of Clement Greenberg, they have often ignored the earlier critics of modernism. This has led feminist art critics to deny the positive aspects of modernism, and accept a Postmodernism that has been unresponsive to the feminist agenda and unfair to women. When feminists demand inclusion in the art world it is necessary to explore the possibility that this goal is best accomplished by following modernist theory and practices as opposed to a Postmodernist theory characterized by an emphasis on the impersonal and possessing a paternalistic and antifeminist avant-garde. In particular, the modernist theory of Roger Fry offers prescriptions for feminist art and art criticism that would be beneficial.

Feminist critics have often embraced a Post-modernism that is impersonal and unresponsive to the feminist Zeitgeist.[5] Joanna Frueh, Cassandra L. Langer, and Arlene Raven concur with this assessment. They state, "Post-modernism has continued the pre-eminence of male art and critics and has ignored and even attacked the validity of a personalist and experiential theory and practice of feminist representation."[6] The concern over the impersonal in Post-modernism is no doubt a reference to the influence of Post-structuralism in Post-modern theory. The problem with Post-structuralism and feminist concerns centers on the former's understanding of the role of the artist and the creative process. Because the artist is not the creator of an original and planned artwork but rather an arranger of pre-existing images or signs, an artist, whether male or female, is not primarily engaged in personal expression, but reflecting the collective society at large.

Another complaint about the current Post-modern scene centers on an antifeminist bias in the artwork of prominent Post-modern artists. Laura Cottingham notes a "new" masculinity in the Post-modernism of the 1980s and 1990s, and gives examples of artists such as Jeff Koons, Eric Fischl, David Salle, Julian Schnabel, Ross Bleckner, Richard Prince, and Matthew Barney, who often produce art that is sexist.[7]

The dissatisfaction that some feminist critics have with the theory and practice of Post-modernism is mirrored in the literature of feminism itself. In recent years writers such as Naomi Wolf, in *Fire with Fire*, Christina Hoff Sommers, in *Who Stole Feminism?*, and Camille Pagila, in *Sexual Personae*, have accused the feminist movement of being dogmatic and discouraging individuality. Naomi Wolf, in particular, believes that the movement has required women to be collectivists and not individuals. She has stated that many mainstream women have been alienated by the fostering of a party line in feminism, including a contempt for making money and requiring conformity on every social issue.[8]

Many feminist art critics continue to accept the "party line" of Post-modern theory despite its anti-individualism and paternalism. Modernism is often poorly understood or stereotyped as patriarchal. Often no distinctions are made between High-modernism and previous modernism, and modernist theory is assumed to be represented by the criticism of Clement Greenberg.

Despite the lack of research that supports differences between men and women, a unique matriarchal art is accepted by many of these critics. The concept of an autonomous matriarchal art is also unsupported and problematic. It is often difficult or impossible to tell the sex of an

artist by looking at their artwork. Although women artists can offer a new perspective on subjects in art such as the male nude or the depiction of women, to mention only two, this interpretation may be accomplished by artists of both sexes.

Matriarchal art is often described in specific Post-modern terms that can limit the creativity of women artists. It is often incompatible with the art of men. Heide Gottner-Abendroth states:

> Matriarchal art is independent of the fictional and is therefore not art in the patriarchal sense of the word. Nor does it require any special technical knowhow. It is rather the ability to shape life and to change it; it is itself energy, life, a drive toward the aesthetication of society. It can never be divorced from complex social action because it is itself the center of that action.[9]

By accepting such an insupportable position, women artists run the risk of limiting their expressive potentials. By narrowing the scope of what women artists should create, they are also inhibiting the potential for their art.

If there is one individual who has influenced feminist art theory almost universally it is the High-modernist critic Clement Greenberg. Most theorists react to his apoliticism, sexism, and narrow definition of high art.

A feminine perspective in analysis and interpretation of artwork is long overdue and necessary; however, judgment of artwork from a feminist point of view is problematic. How does one make the distinction between a great work of art and an inferior work of art when the primary consideration is how that work portrays a particular political point of view? There is a danger when any art is viewed from too narrow a perspective—whether that perspective is political or formal. Much of art, even great art, becomes ignored, passed over, and neglected because it does not fit into the narrow framework of excellence accepted by the current political pundits. Many of the works that receive approval from this narrow point of view may not be otherwise critically evaluated.

Men and women can appreciate the same work for similar or very different reasons. Each person, independent of sex, creates their own reality and arguments for excellence in art. The inclusion of both sexes is necessary to clarify that reality; feminist critics can help enlighten men and other women by interpreting art from their perspective as

women and individuals. Standards of excellence in art and aesthetic theory presuppose that one put aside, at least temporarily, the social context of art and perceive the artifact with few preconceived ideas.

As the poet Fontanelle stated, "I compose and then I think"; the concept of aesthetic perception must remain separate from our usual cognitive functioning. Feminist art theory along with Post-modern art theory in general must acknowledge this separation or the art of women, like the art of men, may become trivial or misdirected, away from the transcendent and intuitive and toward an inferior form of political rhetoric. During Post-modern times the influence of Post-structuralism, in particular, has led to a renewed interest in the related problem of interpreting art as a symbol that carries meaning and reference. Modern sign theory and semiological analysis can be said to have begun with two men, the Swiss linguist Ferdinand de Saussure (1857–1913) and the American philosopher Charles Saunders Pierce (1839–1914).[10] Following Pierce, American philosophers such as Charles Morris, Susan Langer, and Nelson Goodman have continued in this tradition. In Europe, another tradition, begun in the field of linguistics by Saussure, was continued by Lévi Strauss in anthropology and has continued with the work of Jacques Derrida in philosophy. European symbol theory has had the most influence over Postmodern thought.

As we have seen the dispute over whether art is a symbol or an artifact with properties centers on the idea of reference and the acceptance or rejection of the concept of aesthetic perception and experience. Semiological theory ignores the concept of aesthetic experience and focuses on the meaning of a painting or text. Monroe Beardsley believed that this was a critical omission. He believed that there is a tradition of evaluation in art based on the properties of an artwork rather than its reference to things or specific ideas. He noted that many artworks do not appear to refer to anything; an example is nonrepresentational art. He also noted that the characteristic way that one perceives the arts (aesthetically) has a negative effect on the ability of that art to cognitively refer to specific concepts. Beardsley's view was that the artwork's purpose is to aestheticize experience and not primarily to contribute toward "efficient cognition."[11]

One should be aware, despite the current popularity of semiological analysis in the arts, that the concept of art as a symbol is questionable, as is the idea that art is an effective form of social rhetoric. The traditional history of art being linked with aesthetic experience has been ignored. We must also not forget the link between aesthetic experience

and art criticism. If one denies the concept of aesthetic experience, art criticism and the production of art itself may become an exercise in using art merely to advance the cause of political or social agendas. Wasn't this once called propaganda? It can be acknowledged that art contains a political dimension, but most important, it is an aesthetic object. If that understanding is lost or ignored, then a full understanding of art and its value to humans is lost. Without this consideration, art theory and the artworks that emphasize this theory become an anomaly in the history of art. The value of this anomaly is questionable.

One last point regarding the antiaesthetic condition of Post-modern theory is the idea that non-Western and primitive art is equally antiaesthetic in its purposes, appreciation, and use. It may be true that most of the artifacts from these cultures that we label as art are intended for practical purposes that seem to defy aesthetic perception. They are not antiaesthetic, however, since their creation was not predicated on the denial of a pre-existing condition of aesthetic belief. There is a difference between an art created independent of Western aesthetic theory and a Post-modern artist who defies that tradition by creating a conceptual piece that is intended to be nonvisual and antiaesthetic.

In the diverse and antimodernist intellectual climate of Post-modernism, the idea is often expressed that aesthetic experience does not exist, that it is a passé concept and that artwork should serve a more important purpose than producing a nonpractical and personal type of experience. The artifact itself is often thought to be less important than its intended message. The Post-modern art theorist is often directed away from the visual artwork and into specific political positions. Critics are often concerned with context and the idea that their purpose is to describe and instruct the reader rather than offer an evaluation of quality.

But the word criticism implies judgment. Art criticism, whether Post-modern or not, is inherently judgmental. The artists picked as subjects and the work selected to write about already indicate that a judgment of validity or quality has been made even before the first word is written. The process of art criticism involves making decisions of quality, and, in this regard, much of Post-modern theory and criticism is lacking. The aesthetic art theorist and critic is concerned with the context of an artwork but only as an aspect of a larger evaluative process. The primary consideration remains the aesthetic perception of the artifact. Ultimately, Post-modern theory often fails to consider the importance of the physical qualities of the work itself, as well as the existence of aesthetic experience.

26

The Search for
Aesthetic Meaning in
Art Education:
Summary and Conclusions

Viktor Frankel, in *Man's Search for Meaning*, argues that the search for meaning in all aspects of one's life is mankind's primary motivation.[1] But there is also a related search for aesthetic meaning in one's life that needs to be addressed in art education. If humans truly exist for the purpose of understanding the world about them, that endeavor should be encouraged and promoted. A part of that search for meaning is the exploration of those concerns that deal with the aesthetic in life. One wants to know why one can be feeling pleasure, inspiration, a sense of unity, or intensity when one looks at or perceives the arts. There is something about the arts, whether visual or otherwise, that is vital and beneficial to mankind, and makes lives better and more complete. It is difficult to describe that value, because it varies with each person. What one can deduce from the literature is that it has been considered a positive experience that is vital to living a good life. The mere existence of a tradition of aesthetic thinking in the literature of the arts establishes this tradition as a guide to understanding how humans characteristically experience the arts.

The visual arts have had their beginnings in pre-history and are intricately connected with religion, myth, and the commemorating of life's most important events: birth, marriage, and death. They are humankind's birthright and they need to be perceived aesthetically.

Post-modern art theory, which is dogmatically nonaesthetic, has had a detrimental influence on not only the art world but on how we understand and teach the arts. It is important to realize that instruction in the arts that fails to adequately consider the aesthetic tradition obscures the importance of art to humankind. When art education fails to understand the scope and effect of aesthetic creation and perception, it not

only trivializes art but it also fails to assist students pursuing aesthetic meaning in their lives.

It is only with an acceptance of a new art theory allowing for aesthetic consciousness that an aesthetic search for meaning can actually exist. Those concerned with teaching in the arts need to pursue their own methods and strategies for assisting students in aesthetic perception.

The selection of art theorists given, from Alberti to Rosenberg, reveals the limitations of any art theory and critical approach that does not necessarily link the visual arts with aesthetic experience. If one denies the existence of an autonomous aesthetic experience that stands in contrast to our cognitive experiences, a full understanding of the visual arts, as well as all other art forms, is lost. This situation is in large part because of a tradition of aesthetic autonomy and separation from our other cognitive functioning. Monroe Beardsley and others have noted a tradition of viewing the arts as aesthetic objects and not primarily as cognitive symbols. Aesthetic perception seems in many ways different then other cognitive experiences. It does not appear to be sequential in a logical sense but rather immediately revealing or enlightening, as philosophers and aesthetic theorists from De Piles to John Dewey have emphasized.

The aesthetic tradition has been lost to Post-modern art theory for a variety of reasons. One prominent reason is the inevitable resolution of a post-Kantian metaphysics into a form of subjective relativism. The ultimate resolution of dualistic philosophy is that art has the ontological status of only relative and subjective ideas. But as we have seen, this relativism is rather recent in history and when we look back on how earlier aesthetic theorists considered art, it is clear that there is a tradition in art of considering it in part to be objective and transcendent, dealing with universal human traits and emotions.

Looking back on this tradition of both transcendence and aesthetic consciousness, one sees that Leon Battista Alberti revived a suppressed aesthetic consciousness that had been largely dormant since classical times. Alberti was aware of the uniqueness of the experience of art and of its effects on himself and others. Giorgio Vasari helped establish the persona of the artist more than any other writer, but he also emphasized the need for divine mania in artistic creation. The type of quick and vital technique he preferred, that was characteristic of the greatest of geniuses, was more divinely driven by grace than a cool product of reason alone. With the development of classical rules exemplified by the writings of Lomazzo and Bellori, in particular, classical art theory became both more logically based and more dogmatic. Basically the de-

velopment of classical art theory that continued in the French academy and others was characterized by vital debates over the autonomy of art in relation to reason. The French theorists created the term "je ne sais quoi" to express the idea that reason was incapable of fully explaining aesthetic pleasure. Roger De Piles further developed visual classical theory by separating it from poetry because of its unique visual aspects. His description of enthusiasm or the enthusiastic experience of seeing the visual arts is synonymous with modern views on aesthetic experience. With De Piles, the aesthetic became less inferred and more openly described. With the development of Romantic art theory, art increasingly was regarded as the personal expression of the artist and the expressive theory of creation replaced the idea that art was an imitation of an ideal nature. Romantic art theorists such as Baudelaire and Ruskin also supported the concept of the autonomy of art and the aesthetic experience. Art for them involved intuitive thought and was different from rational cognition. British empiricism also influenced art theory, in particular by its emphasis on materialism and pleasure. Even David Hume's skepticism toward the validity of knowledge did not make him consider the arts totally subjective and relative. There was an objective standard for art that few could attain that lay outside the individual. Although aesthetic perception and judgment were subjective (they differed with each person), he believed that there was a transcendent standard that governed excellence in the arts.

The theorists of modernism who followed also supported the concept of art's transcendent status, as well as the concept of aesthetic autonomy. Roger Fry based his ideas on art on the existence of an objectively based "significant form." Clement Greenberg believed art was necessarily directed by an objective and materialistically based evolutionary process resulting in the development of flat abstraction. But he also created the conditions (through his apoliticism and dogmatism) that led to the Post-modern backlash against modernism. Harold Rosenberg, in particular, expressed many of the tenets of this Post-modern reaction. He was prominent in expressing the thoughts, made necessary by twentieth-century analytical philosophy, that art was about ideas and not necessarily an artifact, that craft was an outmoded concept, and that aesthetic experience was either nonexistent or at best of dubious value.

The subjective relativism that rules over present Post-modern art theory is the result of a Kantian metaphysical world. This metaphysical stand has led theorists to give the visual arts and all the arts the ontological status of relativistic and subjective thought. This distorts the

reality of artworks by making them dogmatically subjective. Art may also be considered objective, universal, and objectively material or ideal, and it is important that these alternative views also be taught.

Denis Diderot's unique position (prior to the formulation of a Kantian metaphysics) needs to be reconsidered as an aid to understanding art in all its complexity and preventing the limitations evident in current theory. Diderot's flexible metaphysical position, which is both materialistic and idealistic, seems ideally suited for understanding the vitality of both nature and art. If one considers the visual arts as both material and ideal without forming a necessary duality between the two, a simplistic form of relativism cannot be justified. Simply stated, the conditions for subjective relativism would not exist because other possibilities for understanding the arts would also be valid. If reality is, as so many theorists of the past believed, both subjective and objective, a Kantian metaphysical position with its emphasis on the subjective fails to grasp a traditional understanding of the arts. Diderot's philosophy, even more than his aesthetic writings, brings back a period of metaphysical speculation that was doomed by Kant's philosophy.

It may be necessary to return to this period (the Enlightenment), at least with regard to the practice of comparing and utilizing different worldviews, for the purpose of understanding the conception of art. A new methodology for thinking about artworks is in order, one that necessarily eliminates the possibility of subjective dominance by allowing for multiple worldviews with regard to the ontological status of art. Ultimately the revival of an objective materialism and idealism as valid points of view is mandated. The way one thinks about art is, of course, governed by the way one conceives of reality. But it is clear that conceiving of art as being only about the subjective and personal fails to adequately describe and explain the tradition of thought on the subject, as well as the ongoing creative experience of artists and those who enjoy and aesthetically perceive their art. This trivializes the importance of art for mankind.

It is our society's responsibility and obligation to teach its citizens to appreciate the arts aesthetically. This has most typically been done in art education programs in the public schools. It is, of course, necessary to have art education in the schools because one sees a work of art, be it a painting or sculpture, with one's mind and not an "innocent eye." As stated concerning formalism in art criticism, one must be trained to appreciate the arts and to acquire the value that is inherent in aesthetically perceiving these artifacts.

But what is the value of art? Art education programs have been justified as aiding cognitive thought, improving writing skills, increasing one's understanding of emotions, increasing creativity, helping children go through developmental stages, or acting as a form of therapy. There has been a concern for justifying art education in the past, and a need to justify it today. Initially, instruction in the arts appears less essential in the education of future citizens than courses dealing with scientific rationality. But this is a shortsighted belief, since a society is also required to teach its citizens multiple forms of human understanding that go beyond these cognitive skills. If one wishes to have citizens who can truly have rich and complete lives they need to learn to communicate with the arts aesthetically. They need to understand the importance that art has had to our species, and they need to appreciate the art heritage about them.

But often the aesthetic benefits of aesthetic experience in the arts has been lost to art education programs, and a more limited understanding of the subject has been used to justify art instruction. For example, justifying art education because it would improve one's writing skills, would be dealing with art in a tangential manner. Other activities independent of the production, perception, and evaluation of art, could also improve one's penmanship and may, in fact, do a better job. One could say the same for justifying art education because it may be considered as a form of therapy. It is doubtful that the therapy artwork offers is related exclusively to its unique qualities. Monroe Beardsley pointed out an example of this in "The Aesthetic Problem of Justification."[2] When one plays music to manic-depressives, certain music, whether Beethoven or poorly played commercial jingles, will produce the same effect; that is, an improvement of the mental health of manic-depressives. Other musical masterpieces might worsen the mental health of these individuals. Therefore, there is no intrinsic quality shared by all artworks that will aid in therapy, and it is only incidental that some masterpieces of music will be beneficial.

It is important to differentiate the incidental or tangentially related benefits one gets from art from its primary or inherent (instrumental) value. According to Beardsley, this value must meet two conditions. First, it must be produced by means of aesthetic enjoyment; therefore, it is produced by all works of art. Second, the degree to which the value is produced by the artwork is correlated with the aesthetic value of the work, so the better the work the greater the effect.[3]

Although all masterpieces of art can produce inherent instrumental value, it is first necessary for individuals to aesthetically perceive them.

One can experience Rodin's *Balzac* as a sculpture or as a weighty object whose only purpose is to serve as ballast for a ship. The experience necessary for one to recognize the inherent instrumental value of art must be a particular type of experience, one that satisfies certain conditions and is known as an aesthetic experience. The author believes that art education programs should be justified by the benefits that the inherent instrumental value of art provide for both the individual and society.

It is necessary that at the core of art education theory there be a renewed acceptance of the aesthetic tradition. There must also be an acceptance of the possibility of other forms of perception and understanding, such as intuitive thought. The uniquely human search for understanding the world about us in the most comprehensive and complete manner must be the ultimate goal for art education, and this process must by necessity involve aesthetic experience.

Notes

INTRODUCTION

1. Arthur C. Danto, *After the End of Art* (Princeton: Princeton University Press, 1997), 47.

2. Ibid.

3. Ibid., 48.

4. Lionello Venturi, *History of Art Criticism* (New York: E. P. Dutton, 1936), 325.

5. Ibid.

6. Bernard Bosanquet, *A History of Aesthetics* (New York: Columbia University Press, 1957), 12.

CHAPTER 1. INTUITION IN AESTHETIC APPRECIATION

1. Louis E. E. Duranty, "The New Painting: Concerning the Group of Artists Exhibiting at the Durand-Ruel Galleries," in *The New Painting* (San Francisco: San Francisco Museum of Fine Art, 1995), 43.

2. Ibid.

3. Ibid., 54.

4. Denis Diderot, "The Salon of 1767," in *Diderot on Art*, vol. 2, trans. John Goodman (New Haven: Yale University Press, 1995), 196.

5. Stephen C. Pepper, *World Hypothesis* (Berkeley: University of California Press, 1942), 56–57.

6. Benedetto Croce, "Aesthetics," in *Philosophies of Art and Beauty*, ed. Albert Hofstadter and Richard Kuhns (Chicago: University of Chicago Press, 1964), 365.

7. John Dewey, *Art as Experience* (New York: Minton, Balch, 1934), 249.

CHAPTER 2. AESTHETICS

1. Arthur C. Danto, *The Philosophical Disenfranchisement of Art* (New York: Columbia University Press, 1986), 1–22.

2. Ibid., 21.

3. Remy G. Saisselin, *Taste in Eighteenth Century France* (Syracuse, N.Y.: Syracuse University Press, 1965), 69.

4. Remy G. Saisselin, "Some Remarks on French Eighteenth Century Writings on the Arts," *Journal of Aesthetics and Art Criticism* (winter 1966): 193.

5. Venturi, 146.

6. Theodore Green, *The Arts and Art of Criticism* (Princeton: Princeton University Press, 1947), 389.

7. Rudolf Arnheim, *New Essays on the Psychology of Art* (Berkeley: University of California Press, 1986).

CHAPTER 3. LEON BATTISTA ALBERTI

1. Paul-Henri Michel, *Un Idéal Humain au Xve Siècle: La Pensée de L. B. Alberti* (Paris: Société d'Editions, Les Belles Lettres, 1930).

2. Joan Gadol, *Leon Battista Alberti: Universal Man of the Early Renaissance* (Chicago: University of Chicago Press, 1969), 19.

3. Ibid.

4. Mark Janzombek, *On Leon Battista Alberti: His Literary and Aesthetic Theories* (Cambridge: MIT Press, 1989).

5. Ibid., 10.

6. Ibid., 88.

7. Ibid., 86.

8. See Carol Troyen and Erica E. Hirchlers, *Charles Sheeler, Paintings and Drawings* (Boston: Little, Brown, 1987), and Karen Lucic, *Charles Sheeler and the Cult of the Machine* (Cambridge: Harvard University Press, 1991).

9. Leon Battista Alberti, "Anonymous Life of Leon Battista Alberti," in Franco Borsi, *Leon Battista Alberti* (New York: Harper and Row, 1977), 360.

10. Ibid.

11. Gadol, 213.

12. Cicero, *Selected Works*, trans. Michael Grant (New York: Penguin Books, 1987), 169.

13. Ibid.

14. Alberti, "Anonymous Life," 360.

15. Leon Battista Alberti, *On Painting* (London: Penguin Books, 1991), 88.

16. Ibid., 47.

17. Ibid., 91.

18. Leon Battista Alberti, *On the Art of Building in Ten Books*, trans. Joseph Rykwert, Neil Leach, and Robert Tauernor (Cambridge: MIT Press, 1988), 156.

19. Alberti, *On Painting*, 59.

20. Alberti, *Dinner Pieces*, trans. David Marsh (Binghamton, N.Y.: Renaissance Society of America, 1987), 54.

21. Alberti, *On the Art of Building*, 155.

22. Ibid., 2.

23. Alberti, *On Painting*, 87.

24. Ibid., 75.

25. Monroe C. Beardsley, "In Defense of Aesthetic Value," in *A.P.A. Proceedings* (Philadelphia: American Philosophical Association, 1978), 52, 723–749.

26. Rudolf Wittkower, *Architectural Principles in the Age of Humanism* (London: Alec Tiranti, 1952), 6.

27. Alberti, *On Painting*, 28.

28. Ibid., 77.

CHAPTER 4. GIORGIO VASARI AND THE ORIGIN OF THE IMAGE OF THE ARTIST

1. Irwin Panofsky, *Idea: A Concept in Art Theory* (Columbia: University of South Carolina Press, 1968).

2. Giorgio Vasari, *The Lives of the Artists* (Oxford: Oxford University Press, 1991), 48.

3. T. S. R. Boase, *Giorgio Vasari: The Man and His Book* (Princeton: Princeton University Press, 1971), 119.

4. Vasari, 4.

5. Boase, 119.

6. Ibid., 124.

7. Ibid., 122.

8. Ibid., 125.

9. Ibid., 138.

10. Jakob Rosenberg, *On Quality in Art* (Princeton: Princeton University Press, 1964), 28.

11. Vasari, 464.

12. Ibid.

CHAPTER 5. THE IMAGE OF THE ARTIST AS REBEL AND SOCIAL CRITIC

1. Charles Baudelaire, "Further Notes on Edgar Poe," in *Strangeness and Beauty: An Anthology of Aesthetic Criticism 1840–1910*, ed. Eric Warner and Graham Hough (Cambridge: Cambridge University Press, 1983), 187.

2. Ibid., 192–193.

3. Ibid., 187.

4. Sanford Schwartz, "Clement Greenberg: The Critic and His Artists," *American Scholar* 56, no. 4 (1987): 537.

5. Clement Greenberg, *Art and Culture* (Boston: Beacon, 1961), 7.

6. Jacques Barzun, *The Use and Abuse of Art* (Princeton: Princeton University Press, 1975), 29.

CHAPTER 6. LOMAZZO AND BELLORI AND THE HARDENING OF THE TERM OF IMITATION

1. Alberti, *On Painting*, 74.

2. Moshe Barasch, *Theories of Art from Plato to Winckelmann* (New York: New York University Press, 1985), 278.

3. Ibid., 282.

4. Ibid., 288.

5. Ibid., 321.

6. Ibid., 237.

7. Ibid., 251.

8. Wladyslav Tatarkiewicz, "The Romantic Aesthetics of 1600," *British Journal of Aesthetics* (April 1967): 141.

9. Ibid.

10. Federico Zuccari, "The Idea of Sculptors, Painters and Architects," in *Literary Sources of Art History*, ed. Elizabeth Gilmore Holt (Princeton: Princeton University Press, 1947), 272–274.

11. Giovanni Bellori, *The Lives of Annibale and Agostino Carracci*, trans. by Catherine Enggass (Philadelphia: Pennsylvania State University Press, 1968), 96–97.

CHAPTER 7. THE FRENCH ACADEMY

1. Barasch, 328.

2. Saisselin, *Taste in Eighteenth Century France*, 115.

3. Ibid., 7.

CHAPTER 8. ROGER DE PILES

1. Thomas Puttfarken, introduction to *Roger De Piles' Theory of Art* (New Haven: Yale University Press, 1985).

2. Ibid., 45.

3. Ibid., 70.

4. Ibid., 111.

5. Roger De Piles, "The Principles of Painting," in *Literary Sources of Art History*, ed. Elizabeth Gilmore Holt (Princeton: Princeton University Press, 1947), 411.

6. Frank Chambers, *The History of Taste* (Westport, Conn.: Greenwood, 1932), 109.

7. Jakob Rosenberg, *On Quality in Art* (Princeton: Princeton University Press, 1964), 36.

8. Venturi, 131.

9. Puttfarken, 48.

10. De Piles, "The Principles of Painting," 415.

11. Ibid.

12. Rosenberg, 47.

CHAPTER 9. THE EVOLUTION TO ROMANTICISM

1. David Hume, *Of the Standard of Taste and Other Essays*, ed. John W. Lenz (Indianapolis: Bobbs-Merrill, 1965), 6.

CHAPTER 10. JOHANN J. WINCKELMANN

1. Johann J. Winckelmann, "Thoughts on the Imitation of Greek Art in Painting and Sculpture," in *Literary Sources of Art History*, ed. Elizabeth Gilmore Holt (Princeton: Princeton University Press, 1947), 532.

2. David Irwin, *Winckelmann's Writings on Art* (London: Phaidon, 1972), 12.

3. Ibid., 22.

4. Ibid., 128.

5. Ibid., 97.

6. Ibid., 117.

7. Ibid.

8. Ibid., 50.

CHAPTER 11. SIR JOSHUA REYNOLDS

1. Jakob Rosenberg, *On Quality in Art* (Princeton: Princeton University Press, 1964), 51.

2. Ibid., 66.

3. Robert Rosenblum and H. W. Janson, *Nineteenth Century Art* (New York: Abrams, 1984).

CHAPTER 12. THE SALON SHOWS

1. Joseph Sloane, *French Painting between the Past and Present: Artists, Critics, and Traditions, from 1848 to 1870* (Princeton: Princeton University Press, 1951), 125.

2. Chambers, 125.

CHAPTER 13. DENIS DIDEROT

1. Denis Diderot, "The Salon of 1767," in *Diderot on Art*, vol. 2, trans. John Goodman (New Haven: Yale University Press, 1995), 293.

2. Arnolds Grava, "Diderot and Recent Philosophical Trends," *Diderot Studies* (1963): 4:74.

3. Ernst Cassirer, *The Philosophy of the Enlightenment* (Boston: Beacon, 1966).

4. Ibid., 41.

5. Grava, 75.

6. Cassirer, 90.

7. Aram Vartanian, "From Deist to Atheist: Diderot's Philosophical Orientation, 1746–1749," *Diderot Studies* (1968): 11.

8. Ibid., 55.

9. David Funt, "Diderot and the Aesthetics of the Enlightenment," *Diderot Studies* (1968): 11:16.

10. Ibid., 27.

11. Ibid., 71.

12. Duranty, 43.

13. Denis Diderot, "The Salon of 1767," *Diderot on Art II*, trans. John Goodman (New Haven: Yale University Press, 1995), 196.

14. Ibid., 324.

15. Immanuel Kant, *Critique of Pure Reason*, trans. J. M. D. Meiklejohn (London: Dent, 1991).

16. Beardsley, "In Defense of," 745.

17. Ibid.

18. Diderot, "The Salon," 216.

19. Ibid., 98.

20. Ibid., 196.

21. Denis Diderot, "Letter on the Blind for the Use of Those Who See," in *Diderot's Early Philosophical Works*, trans. Margaret Jourdain (New York: Columbia University Press, 1932), 212.

22. Diderot, "The Salon," 60.

CHAPTER 15. CHARLES BAUDELAIRE

1. Charles Baudelaire, "Further Notes on Edgar Poe," in *Strangeness and Beauty: An Anthology of Aesthetic Criticism 1840–1910*, ed. Eric Warner and Graham Hough (Cambridge: Cambridge University Press, 1983), 187.

2. Ibid., 192.

3. Ibid. ("The Salon of 1859"), 198–200.

4. Ibid. ("The Universal Exhibition of 1855"), 183.

5. Ibid. ("The Salon of 1846"), 180.

6. Ibid. ("Further Notes"), 192–193.

7. Ibid. ("The Painter"), 215.

8. Ibid. ("Further Notes"), 190.
9. Ibid.
10. Ibid. ("The Universal Exhibition"), 185.
11. Ibid.

CHAPTER 16. "ART FOR ART'S SAKE"

1. Ibid. ("Further Notes"), 192.
2. Ibid. ("The Salon of 1859"), 198–200.

CHAPTER 17. JOHN RUSKIN

1. John Ruskin, "Modern Painters," vol. 1, in *Strangeness and Beauty*.
2. Ibid., 76.
3. Ruskin, "The Seven Lamps of Architecture," vol. 1, in *Strangeness and Beauty*, 14.
4. Solomon Fishman, *The Interpretation of Art* (Berkeley: University of California Press, 1963), 27.
5. John Ruskin, *The Poetry of Architecture* (Sunnyside and London: George Allen, 1893), 10.

CHAPTER 18. WALTER PATER

1. Walter Pater, "The School in Giorgione," in *Strangeness and Beauty*, vol. 2, 26.
2. Ibid.

CHAPTER 20. ROGER FRY

1. J. Falkenheim, *Roger Fry and the Beginnings of Formalist Art Criticism* (Ann Arbor, Mich.: University Microfilms International, 1991), 56.
2. Roger Fry, "Art as Form," in *Readings in Aesthetics*, ed. John Hospers (New York: Free Press, 1969), 105.
3. Fry, *Transformations: Critical and Speculative Essays on Art* (New York: Books for Libraries, 1968), 26.
4. Fry, *Last Lectures* (New York: Macmillan, 1939), 76–77.

CHAPTER 21. CLEMENT GREENBERG

1. Clement Greenberg, *Art and Culture* (Boston: Beacon, 1961), 7.
2. Sanford Schwartz, "Clement Greenberg: The Critic and His Artists," *American Scholar* 56, no. 4 (1987): 537.
3. Greenberg, 14.
4. Ibid., 217.

5. Ibid., 243.

6. Steven Foster, *The Critics of Abstract Expressionism* (Ann Arbor: University Microfilms International Research Press, 1980), 56.

CHAPTER 22. ART AS POLITICAL RHETORIC

1. Danto, *The Philosophical Disenfranchisement*, 3.

CHAPTER 23. HAROLD ROSENBERG

1. Harold Rosenberg, *The Anxious Object* (Chicago: University of Chicago Press, 1966), 241.

2. Harold Rosenberg, *Art on the Edge* (New York: Macmillan, 1975), 138.

3. Rosenberg, *The Anxious Object*, 169.

4. Danto, *The Transformation of the Commonplace*.

5. Rosenberg, *The Anxious Object*, 90.

6. Ibid., 92.

7. Ibid., 198.

8. Ibid., 199.

9. Ibid.

10. Ibid.

11. Ibid.

CHAPTER 24. POST-MODERNISM: ANOMALY IN ART CRITICAL THEORY

1. Andreas Huyssen, *After the Great Divide: Modernism, Mass Culture, Post-Modernism* (Bloomington: Indiana University Press, 1986).

2. Hilton Kramer, "The New Philistines," *Art and Antiques* (May 1991): 99.

3. Huyssen, *After the Great Divide*, 157–158.

4. Erika Doss, *Benton and Pollock and the Start of Abstract Expressionism* (New York: Teachers College Press, 1992), 415.

5. Rosalind Krauss, "The Originality of the Avant Garde: A Post-modern Repetition," in *Art after Modernism*, ed. Brian Wallis (New York: New Museum of Contemporary Art, 1984), 13–30.

6. Lucy Lippard, "Andres Serrano: The Spirit and the Letter," *Art in America* (April 1990): 239–245.

CHAPTER 25. FEMINIST ART CRITICISM

1. Cassandra L. Langer, "Against the Grain: A Working Gynergenic Art Criticism," in *Feminist Art Criticism*, ed. A. Raven, C. Langer, and J. Frueh (New York: Icon Editions, 1988), 111–132.

2. Joanna Frueh, "Toward a Feminist Theory of Art Criticism," in *Feminist Art Criticism*, 157–158.

3. Ibid., 157–158.

4. Charlene Touchette, "Multicultural Strategies for Aesthetic Revolution in the Twenty-first Century," in *New Feminist Criticism*, ed. Joanna Frueh, Cassandra L. Langer, and Arlene Raven (New York: HarperCollins, 1991), 182–215.

5. Amelia Jones, "Post-feminism, Feminist Pleasures, and Embodied Theories of Art," in *New Feminist Criticism*, 16–41.

6. Frueh, Langer, and Raven, eds., *New Feminist Criticism*, xii.

7. Laura Cottingham, "The Masculine Imperative: High Modernism, Post Modernism," in *New Feminist Criticism*, 138.

8. Naomi Wolf, *Fire with Fire* (New York: Random House, 1993).

9. Heide Gottner-Abendroth, "Nine Principles of a Matriarchal Aesthetics," in *Feminist Aesthetics* (Boston: Beacon Press, 1985), 84.

10. Arthur Asa Berger, *Media Analysis Techniques* (Newbury Park, Calif.: Sage, 1991), 4.

11. Beardsley, "In Defense of Aesthetic Value."

CHAPTER 26. THE SEARCH FOR AESTHETIC MEANING IN ART EDUCATION: SUMMARY AND CONCLUSIONS

1. Viktor E. Frankl, *Man's Search for Meaning* (New York: Washington Square Press, 1984), 94–95.

2. Monroe Beardsley, "The Aesthetic Problem of Justification," *Journal of Aesthetic Education* (autumn 1966): 29–39.

3. Ibid.

Bibliography

Alberti, Leon Battista. "Anonymous Life of Leon Battista Alberti." In Franco Borsi, *Leon Battista Alberti*. New York: Harper and Row, 1977.

——. *Dinner Pieces*. Translated by David Marsh. Binghamton, N.Y.: Renaissance Society of America, 1987.

——. *On Painting*. London: Penguin Books, 1991.

——. *On the Art of Building in Ten Books*. Translated by Joseph Rykwert, Neil Leach, and Robert Tauernor. Cambridge: MIT Press, 1988.

Arnheim, Rudolf. *New Essays on the Psychology of Art*. Berkeley: University of California Press, 1986.

Barasch, Moshe. *Theories of Art from Plato to Winckelmann*. New York: New York University Press, 1985.

Barzun, Jacques. *The Use and Abuse of Art*. Princeton: Princeton University Press, 1975.

Baudelaire, Charles. "Further Notes on Edgar Poe." In *Strangeness and Beauty: An Anthology of Aesthetic Criticism 1840–1910*, 2 vols., edited by Eric Warner and Graham Hough. Cambridge: Cambridge University Press, 1983.

Beardsley, Monroe. *Aesthetics from Classical Greece to the Present*. Birmingham: University of Alabama Press, 1966.

——. "The Aesthetic Problem of Justification." *Journal of Aesthetic Education* (autumn 1966): 29–39.

——. "In Defense of Aesthetic Value." In *A.P.A. Proceedings*. Philadelphia: American Philosophical Association, 1978.

Bellori, Giovanni. *The Lives of Annibale and Agostino Carracci*. Translated by Catherine Enggass. Philadelphia: Pennsylvania State University Press, 1968.

Berger, Arthur Asa. *Media Analysis Techniques*. Newbury Park, Calif.: Sage, 1991.

Boase, T. S. R. *Giorgio Vasari: The Man and His Book*. Princeton: Princeton University Press, 1971.

Bosanquet, Bernard. *A History of Aesthetics*. New York: Columbia University Press, 1957.

Cassirer, Ernst. *The Philosophy of the Enlightenment*. Boston: Beacon, 1966.

Chambers, Frank P. *The History of Taste*. Westport, Conn.: Greenwood, 1932.

Cicero. *Selected Works*. Translated by Michael Grant. New York: Penguin Books, 1987.

Cottingham, Laura. "The Masculine Imperative: High Modernism, Post Modernism." In *New Feminist Criticism*, edited by Joanna Frueh, Cassandra L. Langer, and Arlene Raven. New York: HarperCollins, 1991.

Croce, Benedetto. "Aesthetics." In *Philosophies of Art and Beauty*, edited by Albert Hofstadter and Richard Kuhns. Chicago: University of Chicago Press, 1964.

Danto, Arthur C. *After the End of Art*. Princeton: Princeton University Press, 1997.

———. *The Philosophical Disenfranchisement of Art*. New York: Columbia University Press, 1986.

———. *The Transformation of the Commonplace*. Cambridge: Harvard University Press, 1981.

De Piles, Roger. "The Principles of Painting." In *Literary Sources of Art History*, edited by Elizabeth Gilmore Holt. Princeton: Princeton University Press, 1947.

Dewey, John. *Art as Experience*. New York: Minton, Balch, 1934.

Diderot, Denis. "Letter on the Blind for the Use of Those Who See." In *Diderot's Early Philosphical Works*, translated by Margaret Jourdain. New York: Columbia University Press, 1932.

———. *Diderot on Art*. 2 vols. Translated by John Goodman. New Haven, Conn.: Yale University Press, 1995.

Doss, Erika. *Benton and Pollock and the Start of Abstract Expressionism*. New York: Teachers College Press, 1992.

Duranty, Louis E. E. "The New Painting: Concerning the Group of Artists Exhibiting at the Durand-Ruel Galleries." In *The New Painting*. San Francisco: San Francisco Museum of Fine Art, 1995.

Falkenheim, J. *Roger Fry and the Beginnings of Formalist Art Criticism*. Ann Arbor, Mich.: University Microfilms International, 1991.

Fishman, Solomon. *The Interpretation of Art*. Berkeley: University of California Press, 1963.

Foster, Steven. *The Critics of Abstract Expressionism*. Ann Arbor: University Microfilms International Research Press, 1980.

Frankl, Viktor E. *Man's Search for Meaning*. New York: Washington Square Press, 1984.

Frueh, Joanna. "Toward a Feminist Theory of Art Criticism." In *Feminist Art Criticism*, edited by Arlene Raven, Cassandra L. Langer, and Joanna Frueh. New York: Icon Editions, 1988.

Frueh, Joanna, Cassandra L. Langer, and Arlene Raven, eds. *New Feminist Criticism*. New York: HarperCollins, 1991.

Fry, Roger. "Art as Form." In *Readings in Aesthetics*, edited by John Hospers. New York: Free Press, 1969.

———. *Last Lectures*. New York: Macmillan, 1939.

———. *Transformations: Critical and Speculative Essays on Art*. New York: Books for Libraries, 1968.

Funt, David. "Diderot and the Aesthetics of the Enlightenment." *Diderot Studies* (1968): 11.

Gadol, Joan. *Leon Battista Alberti: Universal Man of the Early Renaissance*. Chicago: University of Chicago Press, 1969.

Gottner-Abendroth, Heide. "Nine Principles of a Matriarchal Aesthetics." In *Feminist Aesthetics*. Boston: Beacon Press, 1985.

Grava, Arnolds. "Diderot and Recent Philosophical Trends." *Diderot Studies* (1963): 4.

Green, Theodore. *The Arts and Art of Criticism*. Princeton: Princeton University Press, 1947.

Greenberg, Clement. *Art and Culture*. Boston: Beacon, 1961.

Holt, Elizabeth Gilmore, ed. *Literary Sources of Art History*. Princeton: Princeton University Press, 1947.

Hume, David. *Of the Standard of Taste and Other Essays*. Edited by John W. Lenz. Indianapolis: Bobbs-Merrill, 1965.

Huyssen, Andreas. *After the Great Divide: Modernism, Mass Culture, Post-Modernism*. Bloomington: Indiana University Press, 1986.

Irwin, David. *Winckelmann's Writings on Art*. London: Phaidon, 1972.

Janzombek, Mark. *On Leon Battista Alberti: His Literary and Aesthetic Theories*. Cambridge: MIT Press, 1989.

Jones, Amelia. "Post-feminism, Feminist Pleasures, and Embodied Theories of Art." In *New Feminist Criticism*, edited by Joanna Frueh, Cassandra L. Langer, and Arlene Raven. New York: HarperCollins, 1991.

Kant, Immanuel. *Critique of Pure Reason*. Translated by J.M.D. Meiklejohn. London: Dent, 1991.

Kramer, Hilton. "The New Philistines." *Art and Antiques* (May 1991).

Krauss, Rosalind. "The Originality of the Avant Garde: A Post-modern Repetition." In *Art after Modernism*, edited by Brian Wallis. New York: New Museum of Contemporary Art, 1984.

Langer, Cassandra L. "Against the Grain: A Working Gynergenic Art Criticism." In *Feminist Art Criticism*, edited by Arlene Raven, Cassandra L. Langer, and Joanna Frueh. New York: Icon Editions, 1988.

Lippard, Lucy. "Andres Serrano: The Spirit and the Letter." *Art in America* (April 1990).

Lucic, Karen. *Charles Sheeler and the Cult of the Machine*. Cambridge: Harvard University Press, 1991.

Michel, Paul-Henri. *Un Idéal Humain au Xve Siècle: La Pensée de L. B. Alberti* (Paris: Société d'Editions, Les Belles Lettres, 1930).

Panofsky, Irwin. *Idea: A Concept in Art Theory*. Columbia: University of South Carolina Press, 1968.

Pater, Walter. "The School in Giorgione." In *Strangeness and Beauty: An Anthology of Aesthetic Criticism 1840–1910*, edited by Eric Warner and Graham Hough. Cambridge: Cambridge University Press, 1983.

Pepper, Stephen C. *World Hypothesis*. Berkeley: University of California Press, 1942.

Puttfarken, Thomas. *Roger De Piles' Theory of Art*. New Haven: Yale University Press, 1985.

Raven, Arlene, Cassandra L. Langer, and Joanna Frueh, eds. *Feminist Art Criticism*. New York: Icon Editions, 1988.

Rosenberg, Harold. *The Anxious Object*. Chicago: University of Chicago Press, 1966.

———. *Art on the Edge*. New York: Macmillan, 1975.

Rosenberg, Jakob. *On Quality in Art*. Princeton: Princeton University Press, 1964.

Rosenblum, Robert, and H. W. Janson. *Nineteenth Century Art*. New York: Abrams, 1984.

Ruskin, John. "Modern Painters." In *Strangeness and Beauty: An Anthology of Aesthetic Criticism 1840–1910*, vol. 1, edited by Eric Warner and Graham Hough. Cambridge: Cambridge University Press, 1983.

———. *The Poetry of Architecture*. Sunnyside and London: George Allen, 1893.

———. "The Seven Lamps of Architecture." In *Strangeness and Beauty: An Anthology of Aesthetic Criticism 1840–1910*, edited by Eric Warner and Graham Hough. Cambridge: Cambridge University Press, 1983.

Saisselin, Remy G. "Some Remarks on French Eighteenth Century Writings on the Arts." *Journal of Aesthetics and Art Criticism* (winter 1966).

———. *Taste in Eighteenth Century France*. Syracuse, N.Y.: Syracuse University Press, 1965.

Schwartz, Sanford. "Clement Greenberg: The Critic and His Artists." *American Scholar* 56, no. 4 (1987).

Sloane, Joseph. *French Painting between the Past and Present: Artists, Critics, and Traditions, from 1848 to 1870*. Princeton: Princeton University Press, 1951.

Tatarkiewicz, Wladyslav. "The Romantic Aesthetics of 1600." *British Journal of Aesthetics* (April 1967).

Touchette, Charlene. "Multicultural Strategies for Aesthetic Revolution in the Twenty-first Century." In *New Feminist Criticism*, edited by

Joanna Frueh, Cassandra L. Langer, and Arlene Raven. New York: HarperCollins, 1991.

Troyen, Carol, and Erica E. Hirchlers. *Charles Sheeler, Paintings and Drawings*. Boston: Little, Brown, 1987.

Vartanian, Aram. "From Deist to Atheist: Diderot's Philosophical Orientation, 1746–1749." *Diderot Studies* (1968): 11.

Vasari, Giorgio. *The Lives of the Artists*. Oxford: Oxford University Press, 1991.

Venturi, Lionello. *History of Art Criticism*. New York: E. P. Dutton, 1936.

Warner, Eric, and Graham Hough, eds. *Strangeness and Beauty: An Anthology of Aesthetic Criticism 1840–1916*. Cambridge: Cambridge University Press, 1983.

Winckelmann, Johann J. "Thoughts on the Imitation of Greek Art in Painting and Sculpture." In *Literary Sources in Art History*, edited by Elizabeth Gilmore Holt. Princeton: Princeton University Press, 1947.

Wittkower, Rudolf. *Architectural Principles in the Age of Humanism*. London: Alec Tiranti, 1952.

Wolf, Naomi. *Fire with Fire*. New York: Random House, 1993.

Zuccari, Federico. "The Idea of Sculptors, Painters and Architects." In *Literary Sources of Art History*, edited by Elizabeth Gilmore Holt. Princeton: Princeton University Press, 1947.

Index

About the Author

DAVID KENNETH HOLT holds an Ed.D. from Northern Illinois University. He is currently a writer and printmaker living in New Paltz, New York.